MARC CHAGALL

FRANÇOIS LE TARGAT

MARC CHAGALL

RIZZOLI
NEW YORK

© *1985 Ediciones Polígrafa, S. A.*

Translation by Kenneth Lyons

First published in the United States
of America in 1985, by:

RIZZOLI INTERNATIONAL PUBLICATIONS, INC.
597 Fifth Avenue/New York 10017

All rights reserved

Library Congress Catalog Card Number: 85-42875
I.S.B.N.: 0-8478-0624-3

Printed in Spain by La Polígrafa, S. A.
Parets del Vallès (Barcelona)
Dep. Leg.: B. 31.021 - 1985

CONTENTS

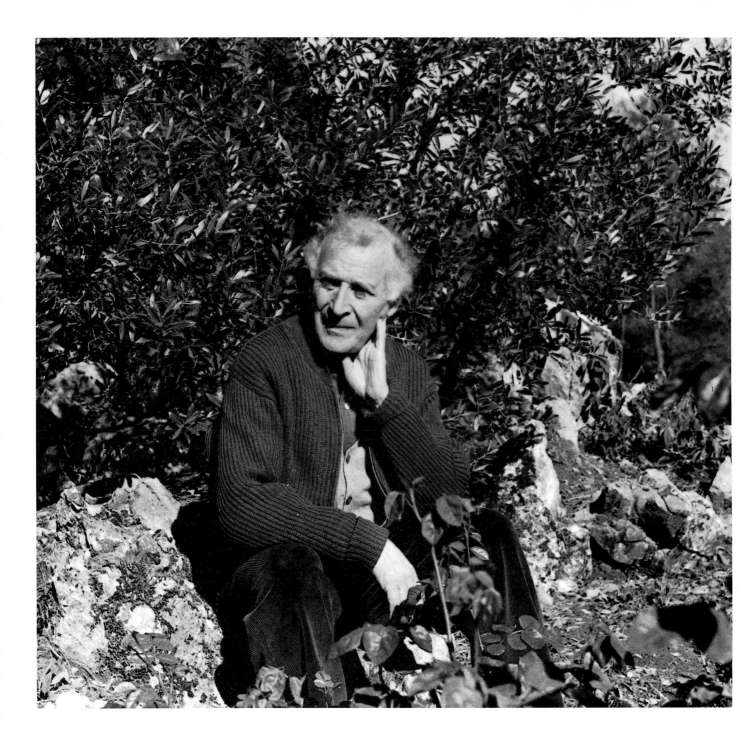

Introduction

"Under the thick layer of our actions the soul of our childhood remains unchanged. The soul is impervious to time." These words of François Mauriac are perfectly applicable to Marc Chagall, who said towards the end of his life: "I am a child who is getting on."

Marc Chagall died on Thursday 28th March 1985, in his ninety-eighth year, and he had not ceased to work until almost that last day. A working career as long as that leaves a considerable number of works.

If we are to understand this work properly we must first of all rid our minds of received ideas about the history of art, which traditionally separates the evolution of a creative artist into periods and genres. We must rediscover the soul of our childhood and give ourselves up to simply marvelling; for this work is imbued with the "marvellous" in the sense given to that word in the 17th century. Is it not "marvellous", after all, to see red donkeys flying through the air, cocks carrying girls off on their backs, a fiddler who has chosen the roof of the house to play his festive tunes?

Chagall once said that he had always "slept quite well without Freud", and he was perfectly right. In any case, the specialists in these matters all agree that for any normal individual everything that has to do with either the subconscious or the unconscious is already decided before his adolescence. Marc Chagall was no exception to this rule; by the time he left Russia for the first time, the die was cast in this respect. And many years later, in 1973, when he was received in Russia with all the honours he so richly deserved, he refused to visit his home town of Vitebsk, fearing to be disillusioned, and said with perfect truth that on leaving the town of his childhood "he had carried it off with him for ever in his heart". Neither fame nor fortune ever caused him to forget that ghetto in Vitebsk where he was born on 7, July, 1887 and where, as yet barely adolescent, he transgressed the Law by drawing human characters and animals, to the great displeasure of certain very devout members of his family; for it is written in the book of Deuteronomy: "Thou shalt not make thee any graven image, or any likeness of any thing that is in heaven above, or that is in the earth beneath, or that is in the water beneath the earth."

That Chagall is a Russian painter, is evident; Picasso said: "One is always the child of one's country." That Chagall is a Jewish painter, in the strict sense of the term, is not quite so certain. He has himself explained his feelings on this score in speaking of the Biblical Message: *"In my thoughts these paintings do not represent the dream of any one people but that of all mankind. They are the result of my meeting with the French publisher Ambroise Vollard and of my journey to the East. It is my intention to leave them in France, where I was born, as it were, for the second time."*

How, then, are we to consider Chagall? A painter, of course, and what a painter! But above all a storyteller. Chagall tells us his life, tells us about himself. He tells us of events, and sometimes even divines them, in the proper sense of the term. For Chagall is a seer, as is proved by some of his Crucifixions.

There are painters who spend their whole lives in their studios, away from the outside world, absorbed in their technical research and incessantly studying and re-studying a fruit bowl or a pedestal table; this was the case of some of the Cubists. But Marc Chagall, although he certainly devoted most of his time to his studio, was too sensitive to life and all its events to shut himself up in any sort of system. In order to approach his work, therefore, we must follow the fructiferous days, happy or dramatic, of his existence; we must, in our turn, make the long, fascinating journey from Vitebsk to Saint-Paul-de-Vence.

From Vitebsk to Paris via St. Petersburg

Marc Chagall was born in Vitebsk on July 7, 1887, in a humble though not wretchedly poor family. His father had a minor job in a herring-curing works; his mother, who eventually had nine children to provide for, of whom Marc was the first-born, opened a little shop to help make both ends meet. At that time Jewish children were forbidden to attend the state schools, but Marc's mother made use of all sort of ploys (including an occasional bribe) to get her son a proper education. And so this eldest son of hers benefited from all the traditional schooling, primary and secondary; and in 1906, at the age of nineteen, he was taken on at the studio of the painter Jehouda Pen. But in fact he was hardly there at all, for at the same time he was serving his apprenticeship as a retoucher with a local photographer. It is clear, then, that from his adolescence Chagall dreamt of nothing but painting, as we may see in one of his earliest works, *The Kermesse*, painted in 1908 (Fig. 1). The die was cast; at the age of twenty-one he was a painter, and in this painting of his youth we already find not only themes but the very spirit of Chagall's whole *oeuvre*. He left for St. Petersburg, where he worked as a photographic retoucher, but he lived there in conditions of abject poverty, since he had not the special permit which Jews needed to reside in the capital. He attempted to obtain the permit as a sign painter, but failed the examination. It was then that he had his first stroke of luck, certainly not a miraculous advance but of capital importance to him at the time. The lawyer and art patron Goldberg took him into his household on the pretence of employing him as a servant, which ensured the granting of the indispensable residence permit. Then he enrolled in an art school where the director, the painter Nicholas Roerich, was not only struck by his work but succeeded in getting him a deferment of his military service. His second stroke of luck came when he met Vivaner, a member of the Duma and a man of considerable influence. It was then that he was able to go with a note of recommendation to see Bakst, the stage designer for the Ballets Russes, who was then the director of the very liberal Swanseva art school.

Bakst quickly realized that the young Marc would only do exactly as he pleased. "Chagall is my favourite pupil," he wrote, "and what I like about him is that after listening attentively to my lessons he takes his paints and brushes and does something absolutely different from what I have told him, which is a sign of a complete personality, a temperament and a sensibility the like of which I have rarely seen." It would be a mistake to believe that this attitude on the young artist's part was a matter of the generational conflict or any sort of "compulsive" disobedience. There was nothing of that about it, as he himself later explained: "If I create with my heart, almost all of my original purpose remains. If it is with my head, hardly anything is left. One should not be afraid of being oneself, of expressing only oneself. If you are absolutely sincere, whatever you do or say will please others. One must always be careful not to let one's work be covered with moss." And then, of course, as Jacques Lassaigne tells us, "the sceptical Bakst understood Chagall's talent, but he always regarded him with a certain reserve, as though suspicious of the younger man's revolutionary possibilities".

In Vitebsk in 1909 he met a girl, also Jewish and seven years younger than he, but of a higher social class. After graduating in literature and philosophy she went on the stage and, indeed, continued her career as an actress until 1920. Chagall, at all events, though rather shy and distant with his men friends, was more at ease in the presence of girls. And Bella Rosenfeld, in her turn, certainly noticed that handsome, elegant young man, described by Efross in 1919 (in the first monograph to be written on the artist's work) in the following

terms: "Chagall has the appealing face of a young faun, but in conversation with him his good-natured affectionateness falls away like a mask and one says to oneself: 'The corners of his mouth are like over-sharp arrows, his teeth those of a wild animal, too pointed, and the blue-grey sweetness of his eyes is too often disturbed by a strange, furious glitter.'" For the moment, however, the young lady saw only the sweetness of the eyes, the good-natured affectionateness and, at the same time, a character who could never keep still. "He gesticulates as if he were afraid to put his foot on the ground. Has he just awoken? His hand has risen and has forgotten to come down again.... I have never seen such faun-like eyes outside the illustrations in a bestiary. When he opens his mouth, I hardly know whether he wants to speak or to bite with his sharp, white teeth. Everything in him is movement, as in an animal standing still but ready to pounce at any moment.... A movement, a pirouette: he is never still for an instant. As though he were afraid of everything. At every moment he is poised to leap into the air and flee." (Bella Chagall, *Lumières allumées*, translated by Ida Chagall).

Is not this description of the young Marc already that of his painting and of the weightlessness that is its chief characteristic? The following year his patron Vivaner — the member of the Duma and important political figure — offered him a grant that would enable him to leave St. Petersburg and go to work in Paris. This was an incredible piece of luck. Leaving Bella in Vitebsk, where she was to wait for him for five years, what did he take with him from Russia? Everything that was already his work: that treasure-hoard of images and sensations that had been accumulating in him all through his childhood. His father at prayer during the Sabbath, the rabbi carrying the Torah, the uncle who played his fiddle on the roof, his grandfather the butcher slaughtering the beasts according to the kosher ritual. He was recalling all this when he wrote: "And as for you, little cow, so naked and crucified, you dream in the heavens. The gleaming knife has raised you into the air." He took with him the memory of the Jewish festivals, cart rides with his Uncle Neuch, the cattle dealer, and the view of the town from the other bank of the Dvina. He had already painted all these elements of everyday life: *The Dead Man* (Fig. 2), *The Kermesse* (Fig. 1), *The Birth* (Fig. 15), *The Holy Family* (Fig. 4)....

But Paris, in the eyes of all foreigners, was the Mecca of the arts, and this first sojourn in Paris was to be of decisive importance in Chagall's career. He himself later expressed it in these terms: "Paris, you are my second Vitebsk."

The allowance he received from his patron was certainly a benediction, but not a gold mine. Arriving in Paris in the late summer of 1910, Chagall was dazzled by the city and by the feeling of freedom he found there; but he had to resort to the solidarity of Russian friends to find living quarters — in an empty flat belonging to one of them. At the end of 1911 he finally found a studio for himself in the Ruche, near the Vaugirard slaughterhouse in the heart of the 15th district. Though the Ruche is now looked back on as a sanctuary of painting and sculpture, it was not a particularly comfortable place at that time. This building owed its name ("the beehive") to its structure: around a central rotunda which had been the wine pavilion of the Paris International Exhibition in 1889, the studios were in fact ranged like the cells in a honeycomb. It was the sculptor and art patron Alfred Boucher (1850-1934), affectionately known as "le Père Dubois," who had the generous idea of buying this pavilion for the benefit of his less well-to-do confrères. All the future masters of the School of Paris lived there at some time, as did many poets — among them Blaise Cendrars, who was to be of considerable importance in Chagall's life.

The Ruche was a sort of phalanstery, teeming with penniless painters who were generally grouped according to nationality. Despite his rather meagre allowance Chagall, who was very methodical, seemed to be the richest of the whole gang — or so, at least, he told Jean-Paul Crespelle when the latter was writing *Montparnasse vivant*. But he saw little of the others. To begin with, he spoke French very badly, which was a handicap. Much has been written about the Ruche in a post-Romantic fashion; the myth of the "accursed" painter had a great vogue in those days, when people were mad about novels with the most sordid settings. We are even told that Chagall, having only one suit and not wanting to stain it, painted in the nude. But apart from Soutine, who was easily the poorest of them all, though none of these young men were rich they did not suffer extremes of poverty. We

need only look at some photographs of the period, particularly those in Janine Warnod's book on this centre of Bohemianism, where we may see the artists painting "from life" in sombre suits and bowler hats worthy of any provincial solicitor. Chagall, at all events, has told us about it himself: "Life in Montparnasse was marvellous! I used to work all night.... When an insulted model began to cry in the next studio, when the Italians sang to the accompaniment of a mandolin, when Soutine came back from the Halles with a brace of putrid chickens to paint, I used to stay alone in my little board-walled cell, standing in front of my easel in the wretched light of a paraffin lamp. For a week, perhaps, the studio had not been swept. The floor was littered with stretchers, eggshells and empty soup tins of the cheapest variety. It was between those four walls that I finally wiped the dew from my eyes and became a painter."

Chagall adopted this Paris which dazzled him. It was there, he always said, that he discovered colour. As for the movements and schools, he never belonged to any of them wholeheartedly. At the Salon des Indépendants he saw the last flickers of Fauvism and the birth of Cubism. Of the first he retained the colour, pure, gay and clear, of the second a certain de-structuring of objects which we find in these major works of the following years: *I and the Village* (Fig. 12), *To Russia, to Donkeys and to the Others* (Fig. 18), thus entitled by Blaise Cendrars, *The Poet (Half Past Three)* (Fig. 14), *Golgotha* (Fig. 20) and the surprising *Homage to Apollinaire* (Fig. 19).

Franz Meyer, whose book — which, unfortunately, only goes as far as 1961 — is the Bible for everything concerning Chagall, writes: "Today the term Cubism is understood, and rightly so, in a very limited sense. But if for once we return to its broader sense, when it was used to denote the whole Parisian movement then influenced by the forms and theories of the Cubists, we are entitled to apply it to Chagall. If we exclude Chagall from the history of that early Cubism, we are denying the process of creative exchanges."

While at the Ruche, Chagall was on familiar terms with all the young rebels of the pre-1914 painting world: Léger, Laurens, Modigliani, Archipenko, Soutine, the Delaunays, Gleizes, La Fresnaye, Metzinger and many others. But it was with the poets, above all, that he established his closest relationships: André Salmon, Max Jacob, Blaise Cendrars (as I have already said) and Guillaume Apollinaire — described by Chagall as "that gentle Zeus" — who on entering his studio exclaimed, "supernatural!" and thus defined the painter's work for evermore.

"The *Homage to Apollinaire*," writes Franz Meyer, "is the most esoteric pictorial symbol that Chagall ever created."

Between 1912 and 1914 Chagall showed at the Salon des Indépendants and the Salon d'Automne, where he had been introduced by the sculptor Kogan, Delaunay and Le Fauconnier. In 1913 he also showed at the Salon des Indépendants in Amsterdam. While continuing to paint, he also did an immense number of drawings; and his work on paper, which is astonishingly forceful and intense, was the cause of a misunderstanding with the Galerie Der Sturm in Berlin, as we are told by Pierre Provoyeur, who was the first curator of the Musée national Message Biblique Marc Chagall in Nice: "Finally, on discovering the works on paper the public may well be led to wonder at the legend of the soft, tender Chagall, when so many of his drawings speak of violence, tension and shouting. In the light of these works one should take a fresh look at certain portraits or, for instance, such works as the 1911-1912 *The Fiddler* in the Guggenheim Museum. It was this atmosphere of clashing and provocation, the de-structuring of the figure in a 'total lyrical explosion,' as André Breton phrased it, that led to the German misunderstanding. At the end of his first Paris period, Chagall sent the Galerie Der Sturm some forty gouaches — among them those in the Rornfeld collection — and pictures which to the Berliners and the prewar artists seemed to be works of German Expressionism. Thus the exhibition was a success and the pictures were bought. Chagall developed a fondness for the capital of Prussia and returned there quite naturally after the failure of his Russian hopes. But the rest of the story is sad: he found some of the pictures had disappeared, and for the ones that had been sold he was paid in devalued money. Chagall left Berlin for France in 1923."

The return to Russia

But first let us go back to Paris in 1914. In that year Chagall decided to make a short stay in Vitebsk and accordingly travelled to Russia, but the declaration of war on August 2, 1914 prevented him from returning to France. On July 25, 1915 he married Bella Rosenfeld. It was around this time that he met the great Russian poets Aleksandr Blok, Essenine, Mayakovsky and Pasternak. He showed twenty-five canvases painted in 1914 at the official Moscow Exhibition and presented forty-five pictures done in 1914 and 1915 at a group show.

From this period date some of his most famous works: *Feast Day* (Fig. 29), *The News Vendor* (Fig. 30), *Over Vitebsk* (Fig. 28) and the series of the old men. "Vitebsk is a quite separate country, a singular town, an unhappy town, a boring town," he wrote in *Ma vie*, the autobiography he published in 1931. And yet he was very much attached to his native place, and when he returned there he painted some fifty "documents" — to use his own term for them — on his family, the townsfolk and the town itself. They are strange, unusual and poetical works. An old man (perhaps the Wandering Jew, says Franz Meyer) passes over the town. Against a red sky (this was the period when Chagall was using anti-naturalistic colours) the figure of the old news vendor stands out with his lugubrious air. Intense contrasts, which Chagall explains in these words: "I had the impression that the old man was green, perhaps a shadow fell from my heart on him." Strange, too, in *Feast Day* (sometimes wrongly called *The Rabbi with a Lemon*) is the presence of the second rabbi, a little praying figure perched on the first one's head. There is nothing to justify his presence in the liturgy of this Succoth, or Feast of Tabernacles.

1916 brought the birth of his daughter, Ida, who was to marry Franz Meyer.

Bella Rosenfeld's entrance into Chagall's life was an event of capital importance — as was to be his marriage, after Bella's death, to Valentina Brodsky. Chagall had the very good fortune to find two exceptional women, the wife of his youth and the wife of his maturity, and this is reflected in his work in the happiest way.

Images of this happiness are the canvases *Over the Town* (Figs. 39 & 43) and *Double Portrait with Wineglass*. Not only did Bella more than deserve her first name (she was ravishing), but she was also very intelligent and a good businesswoman. Chagall thus found himself free from all worldly cares and could give himself up entirely to his painting. But in October 1917, Holy Russia finally toppled over the edge. The change of régime must have been received with joy; the Jews were not tsarists, and with very good reason! The revolution was like a holiday, but it also entailed the establishment of new structures. It was decided to create a Ministry of Cultural Affairs, with three men at its head: Mayakovsky for poetry, Meyerhold for the theatre and Chagall for the fine arts. For Chagall, though he was not yet famous, was at least very well known; and his exhibitions in the preceding years had been successful. It was then that Bella intervened and advised him against accepting the post. She realized, or guessed, the imbroglios in which he might find himself involved: lobbying of all kinds, people trafficking in influence, authoritarianism, all the political infighting for which he was so ill-fitted. Subsequent events were to prove how right she was. For the moment they returned to Vitebsk. Chagall was thirty-one years old and the first monograph on his work — by the critics Efross and Tugendhold — had just been published. He was appointed a commissioner for the fine arts and director of the Vitebsk art school. He may not have had any talent for politics, but on the other hand he had his own very precise ideas about the teaching of art. He also had a great feeling for celebration, as may indeed be seen throughout his work; to mark the first anniversary of the Revolution, for instance, he mobilized all the local artists to decorate the town in the most splendid fashion. Chagall, now a free citizen, was very sincerely in favour of the Revolution. Not because the state had bought twelve of his paintings (at very low prices, incidentally), nor yet because he had been given a room to himself in an exhibition at the Winter Palace in Leningrad, but because he could express his ideas with absolute freedom. "The art of today, as also that of tomorrow, refuses any sort of content. True proletarian art will be that which, in a wisdom full of simplicity, will succeed in breaking with everything that may be defined as purely literary.... Proletarian art is not an art for the proletarians, nor an art of

proletarians, but the art of the proletarian painter. In him the creative gifts are combined with the proletarian consciousness and he knows perfectly well that he and his talent belong to the community." ("The Revolution in Art," 1919). This declaration could hardly be described as suspect. But in spite of it (and in spite of his friendship with Lunacharsky, the president of the Narkompross, or Ministry of Culture and the Arts), he was obliged to leave his school, to which he had brought as teachers such artists as Pougny and Lissitsky — as well as Pen, who had guided his own first steps in painting. Lissitsky, whose work always owed so much to that of Chagall, introduced Malevich. A series of Byzantine intrigues ensued which amounted in fact to mere political manoeuvring. The Party gave its support to Chagall's adversaries and he, an artist pure and simple, refused to play the power game. With Bella he left Vitebsk for Moscow, intending to devote his talents to the theatre, a decision which produced some astonishing works, among them *Sketch for the Introduction to Jewish Art Theatre*, done in 1920 (Fig. 40).

Here, too, Bella's presence was not without its influence on his work for the theatre. We should not forget that she was an actress, though her career was cut short by a fall she had during a rehearsal. For Chagall, moreover, the theatre meant the memory of the enchantments of his childhood; besides, with the new freedom the Jewish theatre was experiencing a revival, becoming aware of its own existence in broad daylight, as it were.

Though no longer director of the Vitebsk school, Chagall continued to teach drawing at the Malakhova and 3rd International colonies for war orphans.

A need to escape

Five years after the October Revolution, which had seemed to be a miracle of liberation, it would seem fairly evident that the iron grip of the new rulers, especially as far as the arts were concerned, made Chagall feel a certain bitterness — and also, perhaps, some degree of uneasiness as to his own future. The evolution of the Marxist policies, which tended to turn the individual into a *homo technicus*, must inevitably have disappointed him, not to mention his treatment at the hands of his enemies Kandinsky, Malevich and Rodchenko. But how was he to escape from this new Russia, where the prohibitions were hardly any different from the ukases of the tsars?

It was the poet and ambassador Jurgis Baltrusaitis, the Lithuanian representative in Moscow, who gave him the occasion he wanted by permitting him to send his works to Kaunas. The chance was too good to be missed and, after a brief sojourn in the Lithuanian capital, Chagall (with his canvases) went on to Berlin, where he suffered the disappointment I have already mentioned. Fortunately, Bella and Ida were able to join him there, and it was in Berlin that he received a telegram from Blaise Cendrars: "Come back; you are famous and Vollard is expecting you." What had happened was that, on leaving the Ruche for the "short stay" in Vitebsk that was to last eight years, Chagall had left some pictures in his studio. Through the agency of some art-critic friends the famous art dealer Ambroise Vollard had seen these works and wished to meet the painter.

Chagall came back, therefore, to France; his Russian life was over and he did not return to his native country until fifty years later, when he was given an official welcome and covered with honours. At his very first meeting with Vollard, the latter, who was also a publisher of bibliophile editions, asked Chagall to do the illustrations for an edition of *General Durakin*. But this was clearly a preposterous idea and Chagall preferred to illustrate Gogol's *Dead Souls* (Figs. 49, 50 & 51). The collaboration between the two men was a great success. In his *Souvenirs d'un marchand de tableaux*, Ambroise Vollard tells us: "One of my most persistent ambitions as a publisher had been to bring out a properly illustrated edition of La Fontaine's *Fables*. In my childhood I had at first detested La Fontaine. My aunt Noémie used to give me fables to copy out as a holiday task and made me thoroughly sick of them. Later, however, many of the poet's verses came back to my memory and little by

little I discovered their charm. When I became a publisher, I promised myself that one day I would publish a La Fontaine.

"It was the Russian painter Marc Chagall whom I asked to do the illustrations for the book. Many people wondered at this choice of a Russian artist to interpret the most French of all our poets. But it was precisely because of the oriental sources used by La Fontaine that I wanted an artist whose origin and culture would have made him familiar with that magical East. Nor were my expectations belied, for Chagall produced a hundred dazzlingly beautiful gouaches. When it came to transferring them to the copper plates, however, so many technical difficulties arose that the artist had to replace them with etchings in black and white.

"It was also Chagall that I commissioned to illustrate Gogol's *Dead Souls*, a work for which he likewise did a hundred etchings for plates and a great number of chapter headings, tailpieces and ornaments of all sorts. Chagall succeeded in rendering with the utmost veracity that rather Biedermeier aspect that was so characteristic of the Russia of Gogol's time.

"But these formidable tasks had by no means exhausted the artist's vein of inspiration, which proved to be still so rich for illustrations that I asked him to do the Bible."

The edition of *Dead Souls* did not come out until 1948, nine years after Vollard's death, and was published by Tériade. As for the Bible, it was to be the source for the artist's monumental work: the Musée national Message Biblique Marc Chagall in Nice.

Chagall was now back in Paris for fifteen years. Raïssa Maritain wrote that "the miracle of France was wrought once again" and that the painter had rediscovered "that spiritual air of freedom in which an artist's personality is heightened and also finds its stability."

While France was going through the decade of the "Crazy Twenties," Marc, Bella and Ida lived there very happily. They did a lot of travelling. For the painter it was a great discovery, that France which he hardly knew, all that different scenery with its different light. "The very countryside of France, in all its diversity, became an object of love for him," says Venturi. His palette was changed by it, as we may see in *Ida at the Window* (Fig. 44), and — to paraphrase Pierre Loti when he wrote: "I have travelled around the world changing my changing soul" — we might say that Chagall, too, changed his soul according to the scenery before him. But what dazzled him most of all was his discovery of the countryside around Nice. He evidently remembered it well many years later, when he settled in Vence and later in Saint-Paul-de-Vence. Another determinant factor for the next twenty years was the memory of his visits to the Louvre during his first stay in France and his encounter with the art of the old masters. During this period he also returned to the theme of men with animals and he rediscovered flowers. Flowers, in fact, became his symbol of the countryside and he used them everywhere, whether in landscapes or in still lifes, such as *Still Life beside the Window* (Fig. 56). Those "Crazy Twenties," as they have come to be called, were years of intense activity for Chagall.

There was also the theme of the circus, one of the variations on which is *The Dream* (Fig. 52). This theme was treated in a series of radiant gouaches, a technique which Chagall had mastered superbly. In spite of all this work, however, Chagall and Bella enjoyed to the full that carefree life of France before the 1929 crash. A significant fact as regards the painter's feelings is to be found in the dedication he wrote for his donation of the engravings of *Dead Souls* to the Tretiakov Gallery in Moscow: "With all the love of a Russian painter for his country." The umbilical cord that bound him to Russia had not yet been cut — was, perhaps, never to be severed entirely.

It was during a retrospective exhibition of his work at the Galerie Barbazange-Hodebert that he made the acquaintance of André Malraux. This first meeting was the beginning of a great friendship, which was to last until Malraux's death in 1976; and everybody knows the important role played by Malraux, when he became Minister for Cultural Affairs, in Chagall's career.

It would be tedious to enumerate all the journeys Chagall and Bella made during those serene years before the Wall Street crash fell like a thunderbolt out of a clear blue sky. His pictures record them in their colours: Brittany with its soft, moist tones, the changing skies

of the Île-de-France and, above all, the sumptuous Mediterranean light of the Midi. His first exhibition in America took place in 1926, at the Reinhart Galleries in New York. In 1931, on the invitation of Dizengoff, one of the pioneers of Israel and the founder and mayor of Tel Aviv, he visited Palestine after a tour of Egypt. This was also the year of the publication, by Stock, of Chagall's autobiography, *Ma vie*, translated by Bella Chagall with the assistance of Ludmilla Gaussel and the editorial advice of Jean Paulhan.

Their trips abroad were numerous: to Holland, for the painter to gain a deeper knowledge of the work of Rembrandt; to Spain, where he discovered Velázquez and El Greco; to Italy and to Poland on the occasion of the opening of the French Institute in Vilnius. 1933 was a year of fateful contrasts. Though Chagall had the pleasure of seeing his talent recognized in a retrospective at the Museum of Basel, he also learned that at Mannheim the Nazis had made as it were an auto-da-fé of his works; for he was both a "Jew" and a "degenerate artist."

American exile and tragedy

The black years were soon to begin. It would appear that there was always a sort of "balancing fatality" in Chagall's life, each happy event having its unhappy counterpart. Though he was awarded the Prize of the Carnegie Foundation, for instance, it was in 1939, just when he and his family had to leave Paris and seek refuge first at Saint-Dye-sur-Loire and then at Gordes, in the Luberon country, which was in the free zone. Then a piece of good fortune was the invitation from the Museum of Modern Art in New York. Chagall at first hesitated, but then took his family to the United States via Portugal, just when the persecution of the Jews in France was beginning. In this case the corresponding misfortune came three years later with the death of Bella, a stupidly unnecessary death due to lack of proper care at the local hospital of Cranberry Lake.

For Chagall her death was the collapse of everything. He was to be a whole year without so much as touching a paintbrush. It was the end of a dream that had come true. To the unsteady young man she describes in her memoirs Bella had brought serenity and a happy life. Thanks to her he had, perhaps, been better able to bear the horrors of war, the anguish of which he had had premonitions and which he had painted in works with titles like *War* (Fig. 105) and *Obsession* (Fig. 73). On September 2, 1944, the day of Bella's death, he wrote: "Everything turns black in my eyes."

Bella, as we have seen, had left notebooks containing her memoirs, and these were now translated by Ida. Chagall was to illustrate these memoirs with drawings full of tenderness. In the spring of 1945 he took the large 1933 picture entitled *Harlequins*, cut it in two and modified the left-hand side, giving it the new title *Around Her* (Fig. 75). The other part was to become *The Lights of the Wedding* (Fig. 76). Then gradually he began to paint again, with rather sombre colours at first, but in the 1945 *Flying Sleigh* (Fig. 74) he regained his perfect mastery.

Something was shattered for ever in his life. He remained in the United States until 1948 and then returned to France. But it was not the same. Always admirably master of his technique, however, he continued to paint. This was the period of the bouquets of gladioli. Some works, like *The Flayed Ox* (Fig. 79) and *The Fall of the Angel* (Fig. 77), possess a truly monumental power. *The Fall of the Angel* had been begun in 1923 and taken up again ten years later; it was finished in 1947. As for *The Flayed Ox*, it is a memory of childhood: Chagall's Uncle Neuch, the cattle dealer, who had given the little Marc rides on his cart and his grandfather, the butcher, ritually slaughtering beasts according to the Jewish law. In his confusion and loneliness, Chagall turned more than ever to the past. But the miracle existed, it formed part of his life. Child that he was, he would not have been amazed to see the Prophet coming to sit at the place left vacant at the family table.

Happiness regained

While widowhood for a woman is a state that attracts sympathy and respect, being a widower somehow seems an abnormal situation. When Bella died Chagall was fifty-seven years old, which for many men is the threshold of old age. Still in love with the Mediterranean world, he settled in Vence. Eight years later, with his marriage to Valentina Brodsky (affectionately nicknamed "Vava"), a new life and a new youth were to begin. In order to continue his work this "child who was getting on" needed more than ever before an intelligent, devoted person at his side. On the strictly physical level, it was to Vava that he owed his longevity. Without her he would not have lived nearly so long in a state of health that permitted him to undertake large-scale works — and that health remained with him until the very last months of his long life.

As far as his work was concerned, without Vava he would never have embarked on such a monumental work as the *Biblical Message*, all the stained-glass windows for cathedrals, chapels and synagogues, the *Ceiling of the Paris Opera House* (Fig. 100), the décor for the Metropolitan Opera in New York or the great mural mosaics. At an age when other artists confine themselves to their last easel paintings, Chagall spurned such slippered ease and tackled works on a scale that would give pause to many a young artist. Picasso was right when he said: "Eighty years of age is the artist's youth."

But at the same time as these great achievements the artist painted many new canvases, inspired by his visit to Greece or simply by his everyday life in Vence or, later, in Saint-Paul-de-Vence. *The White Window*, painted in 1955, is like an ode in the clearest tones to his regained happiness, as is *The Lovers of Vence* (1957), the title of which is sufficient to explain it. With this return of joy the circus, the acrobats and the commedia dell'arte made their appearance in such very strong works as the 1957 *Acrobats in the Night*.

The youthfulness of these works undoubtedly comes from the fact that for Chagall every work he began was like the first picture he ever painted. One is really astonished by his creative powers when one sees the vigour of his last works.

For his ninety-seventh birthday a great act of homage was organized in the form of three important exhibitions: "The Work on Paper" at the Centre Georges Pompidou in Paris, "The Paintings" at the Fondation Marguerite et Aimé Maeght in Saint-Paul-de-Vence and "Stained Glass and Sculptures" at the Musée national Message Biblique Marc Chagall in Nice. He visited all three and one's memory of him there is that of this "child who was getting on" gazing at his own works with all the astonishment of a child for whom this was the last feast-day. Even his own life astonished him. In this regard Jean Paul Crespelle recalls him saying: "My life seems so amazing to me.' To think that it is a poor little boy from Vitebsk who has become what I am! What a long way I have come! I can hardly believe it is true. How could I have been born there, so far away?"

The poor little boy from Vitebsk attained the honour of having his work exhibited at the Louvre during his life-time, in 1977, the very year when he was granted the Grand Cross of the Legion of Honour, the highest of all French distinctions.

The Biblical Message

"Ever since my earliest childhood I have been captivated by the Bible. I have always thought, and still think, that it is the greatest source of poetry of all time. Since childhood, then, I have sought this reflection in life and in art. The Bible is like an echo of nature and it is this secret that I have endeavoured to transmit."

He had a first chance in 1931, when Ambroise Vollard asked him to illustrate the Bible. He then painted a series of large gouaches, which were the starting-point for the *Biblical Message*. This *Biblical Message* is a cycle, of the same familiar genre as we find in the *stanze* of the Vatican or in the Galerie François Iᵉʳ in Fontainebleau. It presents a

continuous and coherent decorative programme, the reading of a story as it were, as in an open book. The first place Chagall thought might be suitable for painting this cycle was the Chapelle du Calvaire in Vence, which he was shown in January 1950. But it was not until twenty-three years later, on July 7, 1973 (his birthday), that the Musée national Message Biblique Marc Chagall was inaugurated on the hills above Cimiez. This creation of a national museum was made possible thanks to André Malraux, at that time Minister for Cultural Affairs and a very old friend of Chagall, and to the city of Nice, which gave the site. The State undertook the building work, Chagall, his wife and his daughter Ida made important donations, and the first stone was laid by the architect André Hermant, who designed a building specially to contain the cycle that the artist wished to create. He even visited Israel and was fired with the desire to give the walls of the museum the same nobility as the walls of Jerusalem.

The material used came from the quarries of La Turbie and was the same grey, pink and blue stone as was used in the first century of the Christian era to build the Trophée des Alpes, the monument that stands high above Monaco. It is certainly an exemplary museum, for it was built expressly for the works it was to contain.

The principal hall is occupied by twelve pictures of very large proportions, illustrating the great moments of the Bible: *The Creation of Man, Paradise* (Fig. 98), *Adam and Eve Driven out of Paradise* (Fig. 90), *Noah Releasing the Dove* (Fig. 63), *Noah and the Rainbow, Abraham and the Three Angels* (Fig. 91), *The Sacrifice of Isaac, Jacob's Dream* (Fig. 89), *Jacob Wrestling with the Angel, Moses Before the Burning Bush, The Striking of the Rock, Moses Receiving the Tables of the Law.*

Another room, adjacent to this, is reserved for the five representations of the *Song of Songs* (Fig. 88). Facing a pool we find a monumental mosaic, *The Prophet Elijah* (Fig. 148), executed by Lino Melano. In the entrance there is a tapestry woven at the Gobelins factory by Yveline Lelong and in the concert and lecture hall are the three great stained-glass windows of *The Creation of the World* (Fig. 150) — not to mention the harpsichord, the lid of which was painted by Chagall himself. Among other numerous donations the artist presented a group of statues, which are housed in a room of their own. Temporary exhibitions are regularly held in the museum, but their subjects are carefully chosen: they must be the works of dead artists and only of a spiritual character.

It cannot be too carefully stressed that the *Biblical Message* is not intended to be either imagery of the Jewish religion or Sionist propaganda. Chagall always vigorously resisted any such interpretation. We need only recall the inscription he placed on the mural ceramic in the baptistery of Notre-Dame-de-Toute-Grâce in the Plateau d'Assy: "In the name of the freedom of all religions."

"In my thoughts these paintings do not represent the dream of any one people but that of all mankind. They are the result of my meeting with the French publisher Ambroise Vollard and of my journey to the East. It is my intention to leave them in France, where I was born, as it were, for the second time."

Chagall, then, was certainly a Russian painter, but certainly not a Jewish painter, strictly speaking. Besides, the number of *Crucifixions* he painted shows quite clearly that in this, too, he was transgressing the Jewish law. "Instead of being astonished," wrote André Pieyre de Mandiargues, "one should find it normal, almost necessary, that Marc Chagall, born into an ancient tradition of Jewish mysticism, has throughout his career painted pictures rendering homage to Christ and the Crucifixion." The same author went on to say, in a particularly felicitous phrase: "Christ is a poet, and one of the greatest poets, thanks to that incredible, senseless way in which he chose to bear his suffering." Charles Sorlier, for his part, believes that it is a question of metaphor: that it is not Christ who is suffering the ordeal, but innocence, purity, goodness. In the 1912 *Golgotha* (Fig. 20), moreover, it is a child who is placed on the cross, while in *The Martyr* (Fig. 67), that premonitory work painted in 1940, the man bound hand and foot and wrapped in a tallith, or prayer shawl, represents the whole Jewish people being sacrificed.

On the occasion of the retrospective exhibition at the Grand Palais in 1969, Jean Leymarie wrote: "Like many other Jewish artists or philosophers, Chagall is overwhelmed by the solitary image of Christ assuming beyond all dogmas the highest form of humanity;

in expiring with his arms outspread on the Cross, in a supreme gesture of love and sacrifice, he prepares to receive the plenitude of the reality he has redeemed. Chagall himself has told us that for him Christ is 'the man with the most profound understanding of life, a central figure for the mystery of life.' First appearing in 1909 and crystallizing in *Golgotha*, the mysterious masterpiece he painted in 1912, the theme of the Crucifixion — which in his eyes combines the symbols of the two Testaments — has since 1938, when he created the poignant *White Crucifixion* (Fig. 68), embodied the whole tragedy of the world.''

Pierre Provoyeur summarizes this ambiguity in the following terms: ''Christ, as victim of persecution, abandons the nimbus of his divinity to bear witness more than ever to his humanity and to the holocaust. Chagall a Jewish painter? Not if we examine the whole of his *oeuvre*, discounting the pictures of strictly religious content. Inclined to be suspicious of any possible utilization of his work in this sense, the artist has always insisted that his intentions are spiritual and poetical, but not confessional. The *Biblical Message*, though constituting a veritable testament in the field of his experience as a plastic artist or in that of his basic philosophical preoccupations, represents the work of a painter and not an attempt at propaganda. To benefit whom or what, in any case, since Chagall has covered his tracks so effectively that neither Jews nor Christians can appropriate this or that image from the Torah, this or that Crucifixion, to speak of proselytism or sacred art? And yet the whole Bible is there, sensuous, tragic and universal. One of the constants in Chagall's art and thought is his endeavour to approach the mysteries of nature and man's presence in the world.''

But the Musée national Message Biblique Marc Chagall is more than a museum. On the spiritual level it may be compared to the chapel — and even then the word is unsuitable — which John and Dominique de Menil caused to be built in Houston and for which Rothko painted some very large-scale works. There is no comparison as far as art is concerned, of course, but there is certainly the same desire for an ecumenical meeting place, a place for meditation and, as far as the *Biblical Message* is concerned, a place for the celebration of spirituality, since the concerts or lectures given in the hall intended for such events are always devoted to this theme.

Chagall and his themes

Chagall is a storyteller, and it is through the magic of his stories that he attains universality. His greatest interests are the Bible, that marvellous story, and the world of entertainment, most particularly the circus. His whole *oeuvre* is a festivity, for he has the feeling of celebration. Being Russian, after all, how could he fail to be fascinated by that world of the circus that arrived from Byzantium in the 10th century? He identified fully with tumblers, clowns and comedians, if we are to believe Jean Cassou, who wrote: ''He is a farcical, burlesque, profoundly comic genius.'' Which is fair enough as far as it goes, but does not go nearly far enough. For Chagall moves in a miraculous world in which everything may at any moment be transformed. And this sense of the miraculous and marvellous was what characterized the spirituality of the Hassidim, one of the Jewish sects, of whom Werner Haltmann writes as follows: ''The legends, in the form of allegories full of images, with which they adorned their doctrine of the omnipresence of their hidden God all had as their starting-point this marvellous image: when the full flood of the love of God filled the vase of the world, this vase was shattered into innumerable objects and each of these thus contains a portion of divine love. Thanks to this, the simplest thing acquired legendary possibilities, the world became more transparent, reality and legend interpenetrated.'' It is more than possible that this mystical interpretation of the Bible, which won the hearts of the Jewish population of Central Europe in the 18th century through the Hassidic movement founded by Baal Shem Tov, had a profound influence on the painter's perception of the world. He goes beyond mere representation. ''When I paint the wings of an angel, these

wings are also flames, just as they are also thoughts or desires.... We must do away with the idolatry of the image.... Judge me on my form and colour, on my vision of the world, and not on isolated symbols. One should never paint a picture on the basis of symbols. Rather than starting out from a symbol, one should end with one, for symbolism is inevitable. Any absolutely authentic work of art automatically possesses its symbolism.'' That is why the world of entertainment, and especially that of the circus, has a different dimension in Chagall from what we see in representations of this world by other painters. In his work, therefore, we should not try to find a transposition of reality — or reportage, as they say nowadays — but the ideal occasion of a dream.

With Chagall nothing remains of the strict truth. Vercors, in his analysis of the 1943 work *The Juggler* (Fig. 71), says: "In this painting of *The Juggler* nothing remains itself: the acrobat becomes a cock; the naked breast, veiled by a fan, becomes at once a widow and a horse; the clock folds softly over an arm like a chasuble.... In a number of other canvases the women are stretched into comets, the fiddles change to faces, cocks, donkeys, tumblers.... One would never be finished listing, throughout this immense *oeuvre*, the thousand metamorphoses that flow from the colours on his canvas, just as in the eyes of children they pour from the clouds in the sky....'' (*Derrière le miroir*).

Vollard once asked Chagall to paint a series of gouaches on circus themes. The project was eventually dropped, but Chagall sent the dealer the collection of gouaches he had done under the title *Vollard Circus*. In them we see such sights as a huge he-goat smoking as he enters the ring; a clown with an open umbrella riding a four-headed monster; the Eiffel Tower, also smoking and balancing on a donkey; an equestrienne lying down on her mount, like a new Venus. This theme of women carried off by animals is frequently found in Chagall's work outside his circus paintings. There is, for instance, *The Cock* (Fig. 58), which shows a girl riding on a cock as though in a version of the *Rape of Europa*; and, above all, that strange picture *The Dream* (Fig. 52). André Pieyre de Mandiargues, for whom Chagall is "the poet painter *par excellence*" of our age, describes *The Dream* as a work of "exemplary magnificence." In this astonishing picture there is a sort of allusion to Carroll's *Alice in Wonderland*, for the great hare on whose back the girl is lying is surely of the same race as the March Hare in that book. The moonlit landscape is represented in reverse, a world of reflection and unreality, and one can understand why the Surrealists were so sorry that Chagall never consented to join them.

The circus is, of course, the universe of clowns, jugglers and acrobats, but it is also that of animals, another theme dear to Chagall. Always present in his work, they are not taken from a bestiary but rather from family memories. The most significant animals — cow, bull, donkey, horse, goat, cock, fish — appear and disappear according to the period. The donkey and the horse are to be found after 1924, the fish and the cock after 1928. During the first Parisian period the ones we most often find are the cow, the goat and the bull. Of course Chagall is not an animal painter. But as he paints life, animals form part of his universe and even play a conciliatory role between the Divinity, nature and man. One need only look at that poignant picture entitled *Solitude* (Fig. 59), in which we see a rabbi sitting in despair and clasping the Torah, while a placid little white cow gazes at him in astonishment. She represents the peace of the world confronted with the tragedy that was imminent — for this canvas dates from 1933. "Animals never let you down," Chagall used to say. Certainly, the cocks are red, the donkeys blue or green, but that does not matter in the least. Charles Sorlier, who did a lot of work for Chagall — as master lithographer at the Mourlot atelier, but also giving invaluable assistance with the monumental works — describes the painter's attitude as follows: "There he needs a red to balance a blue or a green. Why not a red cow? Or a green one? But whether it's red or green, the cow Chagall places on his canvas is in harmony with the rest of the composition." There we have the attitude of a true painter; for a picture is a flat surface covered with harmoniously arranged colours. Thus Chagall never fails to surprise us, even in his portraits or characters: *The Green fiddler* (Fig. 34) and, above all, a 1966 *Portrait of Vava* (Fig. 106), in which the sitter's green face is flanked by an animal's head in red — a surprising picture on more than one score. Chagall is not really a portraitist in the traditional sense of the term. He has always refused commissions of this sort. For him a portrait is not so much a likeness as an

act of loving homage. He may have done a pencil portrait of Dr. Eliacheff, but everybody knows that Bakst never saw the portrait he had commissioned from Chagall, while that of Chaplin (Fig. 57), though it is a marvellous drawing, has none of the features one expects in a traditional portrait. His subjects were always those closest to him: his mother, his first wife Bella, his daughter Ida, Vava. This portrait of Vava is symbolic in its colours: the face is green because for Chagall this colour meant light. It is likewise symbolic in spirit, recalling one of the works of his youth, *The Pregnant Woman* (Fig. 16), in which the unborn child is represented in an oval, on or in his mother's womb. Here Vava bears on or in her a couple of lovers tenderly entwined and it seems clear that this couple is meant to be himself and Vava, a symbol of their union.

He painted some admirable portraits of Bella: *My Fiancée in Black Gloves* (Fig. 3) and *Bella in a White Collar* (Fig. 33); and he also represented her with him in *Double Portrait with Wineglass* and in *Over the Town* (Fig. 43). Crazy imagined excursions, the lovers gliding in their newfound happiness, escaping into an inner world of their own. Now let us compare these 1917-1918 canvases with *The Stroll* (Fig. 132), painted in 1973. This is a very sober picture, with no wild whirling through the air. It represents the painter and Vava, but joined together in a single body with two faces. Sixty years earlier, in *Homage to Apollinaire* (Fig. 19), he had also painted a man and a woman, Adam and Eve, in which only the busts and heads were separated.

From the circus to the opera was but a step and Chagall took that step quite nonchalantly. In his youth, after all, he had done décor for the theatre and in particular for the Jewish theatre, in the heyday of its revival following the October Revolution. This work for the stage had included the sets for Gogol's *The Government Inspector,* Synge's *The Playboy of the Western World* (Fig. 41), Scholem Aleichem's *The Miniatures* and — after meeting Alexis Granovski, director of the Jewish Theatre — several large-format paintings, among which was *Introduction to Jewish Art Theatre* (Fig. 40).

As for opera proper, he was not to tackle it until much later, when he was in America during the Second World War. Though, like all artists who discover America, he was fascinated by "the American space," Chagall was rather bored during this exile, despite Bella's presence. Since he could not speak English, he had to confine himself to banal conversations in Yiddish with the local shopkeepers. In 1942 he went to Mexico to do the décor and costumes for the ballet *Aleko*, on the theme of Pushkin's *Tziganes*, with music by Tchaikovsky and choreography by Léonide Massine. There he found once again all the Russian universe that was so dear to him and created a world of fabulous magic that could hardly have been more different from the verist décors his master, Bakst, had done so many years before for the Russian Ballets. Then Lucia Chase, who was then directing the American Ballet Theatre in New York, commissioned Chagall to do the décor costumes for a new production of Stravinsky's *The Firebird*. Here again he did exactly the opposite to Bakst, who had created the décor and costumes for the ballet's first performance in 1910. Chagall invented new colours, more sensuous, barer, closer to the musical echoes of the work. All the magic of old Russia was there, the princess, the sorcerer, the acrobat and the dancers embodying "the marvel."

The publisher Tériade had commissioned Chagall to illustrate the story of Daphnis and Chloe. As is well known, Maurice Ravel had written a ballet on this theme and Fokine decided to do the choreography. The year Chagall married Vava, they went together to Greece. He was dazzled, living his own subject. "Thus was born one of the most beautiful drop curtains one could hope to see: the exuberance of nature reveals a purity that is at once absolute and generous, delirious and sober, without any sort of contradiction. A flower-bird passes, faces appear as though in a dream. The dancers seem to have sprung forth from ochre frescoes, from the rose-pink earth. Daybreak." It was in these terms that Martine Cadieu saw this décor, and it was in equally poetic vein that she spoke of *The Magic Flute* (Fig. 107), undoubtedly Chagall's masterpiece in the field of opera. This was the opera chosen for the inauguration of the new Metropolitan Opera in New York, on February 19, 1967. Thus again we find Chagall in New York, summoned by Rudolf Bing — who had admired his painting since 1919 — to this encounter with Mozart. Thus we have *The Magic Flute.* Look: the sun like a monstrance, the shadow of the Ladies of the Night.

Tamino as a weightless flame, an explosion of purple in the darkness. Love triumphant. Two great frescoes for the Metropolitan Opera, but also the décor, the costumes, the very heart of the spectacle. And in the background, behind all this magic of colour, the restless questing — that of Mozart, that of Chagall — that brings together the dream of the miracle, the spectacle of the sacred, the life of death. In its flashing regard, in the tilted head, Chagall's 1912 *Self-Portrait* certainly has some resemblance to Tamino. Marc listens to Pappageno's birds, opens the door of their cage and frees us all from the prisons of reality.

For the walls of the theatre of Frankfurt, in 1960, he had chosen as his theme the commedia dell'arte. Three years later André Malraux, on the invitation of General de Gaulle, commissioned him to paint the *Ceiling of the Paris Opera House* (Fig. 100). Chagall was now seventy-seven, but perfectly able to clamber all over the scaffolding. The vast studios of the Gobelins' tapestry factory were placed at his disposal for this gigantic task and, as in the case of all his monumental works, he could rely on the assistance of Charles Sorlier. The work was much criticized, of course, by the very people who had never raised their heads to look at the ceiling painted by Lepneveu, an academic painter of the eighteen-seventies. But the finest homage it received was not only the satisfaction of the Minister for Cultural Affairs, André Malraux, but a poem by Louis Aragon, of which I quote just one verse:

> *"You paint that legend called the human soul;*
> *You paint that endless game of lovers met;*
> *You paint that divine fire whose realm I am;*
> *You paint that mad life like an epiphany."*

It is certainly the most renowned of all his works.

Chagall's techniques

Drawing

While Chagall did not revolutionize the art of drawing as Matisse and Picasso did, he nevertheless remains one of the greatest draughtsmen of his time, original and unburdened by theories, letting the subject dictate the technique. A drawing for him is not a record of reality in the manner of a photograph, but rather a creation: from the confrontation of black and white the colour is born. For him drawing is an act of love.

Though he drew throughout his long life, in his graphic work there are certain particularly brilliant periods. The first of these was that of his first sojourn in Paris, from 1910 to 1914, and coincided also with the avant-garde research of the time. In proof of this we have the finished sketches, as also the rapid preparatory drawings for two major works, *Homage to Apollinaire* (Fig. 19) and *Golgotha* (Fig. 20). Here the chronological presentation of an artist's work is not arbitrary. Thus the illustrations done for the review *Der Sturm* between 1914 and 1918 herald the work he did in Russia until 1922; the techniques he used, stencils and collages, were new and expressed a certain fantasy, though this was sometimes contradicted by an almost brutal gravity and severity, as in *The Odalisque* (Fig. 23), done in 1913-1914, or in the 1911 *Cain and Abel* (Fig. 10).

It was also during this period that Chagall found a new application for his drawing: representing the world of entertainment. From his first sketches for the Jewish theatre to the sumptuous sets for *The Magic Flute* in 1967, this is a whole world of quite different creation that is integrated into the whole body of his work. Chagall is not simply a painter who does décor for the theatre; his décor designs form an integral part of his work, as do his illustrations for books, from the nineteen pen-and-ink sketches for H. Lessin's book, published in New York in 1936, to the drawings for André Malraux's *Antimémoires*.

As regards drawing for its own sake, this became rarer during his second Parisian period but reappeared in great strength in his later years. It is a new world, more intimate and personal, that one discovers in these grey and white washes and watercolours which often echo, though without copying them, his favourite compositions. Quite rightly regarded as the magician of radiant colour, Chagall is also a great master of sombre tones, as we may see in the gouaches for *The Bible* commissioned by Vollard in the thirties.

As for drawing technique properly speaking, that of Chagall is versatile and shows no particular signs of evolution. The thick strokes and black stains of the years from 1910 to 1914 were used as best fitted to their subjects, unrefined subjects like *Peasant Eating* (Fig. 26), *The Jew with the Stick* (Fig. 25) or *The Old Man* (Fig. 27). But side by side with these he used a fine, tremulous line in works like *Self-Portrait with His Parents* (Fig. 11), done around the same time. This duality was to recur in later years: the thick blacks of the 1949 *The Horse* (Fig. 80), for instance, contrasting with the lightness of the stroke in the 1954 *Tériade's Garden* (Fig. 81) or in *Tériade's Window* (Fig. 82), also done in 1954, with its reminiscences of Matisse. Separate mention must be made of the prodigious portrait *My Mother* (Fig. 24), done in 1914, undoubtedly one of the most beautiful drawings he ever did and a worthy follower in the great tradition of Rembrandt.

In 1926 came the illustrations for the *Fables* of La Fontaine (Figs. 53, 54 & 56). The attempt to tranpose them to coloured engravings having failed, three years later Chagall took them up again himself in black and white. This was the richest of his series of engravings, with its animals full of fantasy, and in *The Circus* (Fig. 130) one finds all the artist's magnificent sense of humour.

Lithography

Chagall took an interest in all forms, all techniques. For him there was no such thing as a minor art. His posters were done with just as much care as his pictures, among them *The Mermaid of the Baie des Anges* (Fig. 94), commissioned by the mayor of Nice in honour of his town.

Though he had done some lithographs and engravings in earlier days, it was not until his return from America in 1948 that he began a career as a lithographer painter and also took up the art of stained glass. He was to work in the two most important ateliers for these arts, the Mourlot atelier for lithography and the Jacques Simon atelier in Reims for stained glass. At the Mourlot establishment he met Charles Sorlier, with whom he was to work for the rest of his life. It was Sorlier, when Chagall was looking for a master glassworker, who recommended him to Charles Marq, heir to the craft tradition of the Simon family in Reims.

Charles Sorlier, master lithographer in the Mourlot atelier, has told us how Chagall worked in this field: "Chagall is a simple man, the workers all adore him. When he is expected at the printing works, where he often comes to work, he is awaited like the spring, welcomed as a friend. 'Bonjour m'sieur Chagall'; his arrival is greeted with gay, friendly exclamations. There is never any ceremonial to welcome this great painter — whom one forgets to call 'master', but who is delighted to feel so much at home. Let us leave him, then, to settle down in his usual place, in the atmosphere of friendship that is indispensable to his work, with his usual helpers. Confronted with the spotlessly clean stone that awaits him, Chagall first makes a movement of retreat, of timidity, but then the drawing begins. Chagall draws on the lithographic stone just as he paints on his canvas. No masterly arrangement of the elements, no categorical affirmations.

"He has plenty to say, plenty to explain, plenty to make people love. His serious, complex message cannot be condensed in an expeditious formula and his work is slow and punctuated by hesitations, dissatisfaction and second thoughts. Suddenly you may see a woman's profile in a corner being transformed into a cock, a pretty little cow tuning her fiddle....

"Great enough to adopt a modest attitude, humble, attentive, easily moved, diligent, always in love with his trade and not easily satisfied with his own work, he caresses the

stone and takes up the task again a hundred times so as to give his work the utmost subtlety. Any sort of violence is alien to him, he has a physical horror of brutality and of the stupidity it betrays. Chardin recommended sweetness, Chagall demands tenderness.

"Chagall's work in lithography is original work. I do not want to get involved in the eternal argument about original lithographs, but as far as Chagall is concerned he creates on the stone or the zinc. And when I did some engravings of Chagall's works, engravings that were works of interpretation and not just copies, he was the first to say: 'You must sign them after me.' Besides, since these works are printed in very small numbers, they are not just multiples done to make his pictures more widely known, but original works in themselves. Only very rarely does he reproduce a picture in a lithograph, but he has been known sometimes to paint pictures after his lithographs. He creates as a lithographer. He is passionate about his work and very demanding in everything concerning it, but a delightful man to work with.

"He is a craftsman, just like Picasso. He likes to participate completely, which is what has led him to do ceramics, a true craftsman's trade. Tapestry, for instance, does not interest him so much, because he only does the model and it is the weaver who produces. For him it is like a cherry tart on which he cannot move any of the cherries around. He is particularly interested in the manual side of lithography.

"When he did... a lithograph in front of a television camera, he paid no attention at all to what was going on around him. One would have said that he was alone there, with no other company than that of an angel, one of those angels he paints. And that angel entered the composition of the lithograph, after the couple and the animals."

Stained glass

It was in 1957 that Chagall did his first stained-glass windows and they were done for the church of Le Plateau d'Assy in Haute-Savoie on the request of Father Couturier, the monk who really started the revival of religious art in France. It was a comparatively modest job, considering the dimensions of this little church in the mountains. But that same year he received the commission for the windows in the cathedral of Metz (Fig. 149). This was a monumental task, which he undertook with the master glassworker Charles Marq. The latter has told us all about this adventure, which was followed by many others:

"Marc Chagall, in this perhaps resembling certain painters of the early Renaissance, has the gift of inspiring his assistants. Far from insisting on fidelity to the model (a work perfect in itself and impossible to remake), he mysteriously incites you to relive his creation by means of another art. And that love that he demands has the force we are all familiar with, stronger than the best of intentions. I remember our first conversations. Chagall had just been commissioned by Robert Renard to do the stained-glass windows for Metz. After the two little windows at Assy he now had to tackle the coloured world and immense space of a great Gothic cathedral. We talked about the aspect of the windows, about the way in which the forms are gradually reduced in Gothic buildings; but above all we talked about the light piercing the work, ready at any moment to make it explode, heightening the radiance of the tones, transforming the shapes according to their transparency or opacity: an absolute power, in short, to which form and colour were subordinate. It was not a question of technique, leads, the scale of the windows....

"Having examined the model, the painter's first proposal, Chagall now wanted to hear my own proposals, which this time did have to do with types of glass and lead. And when he said: 'Now show me what you can do', it was clearly a demand for freedom, a belief in the ability of our humble hands, if God willed, to let the creation pass. He shows us humbly that his genius is greater than he, so great that it can even dwell in others.

"He comes into the workshop with the punctuality of a craftsman who knows that it is only by hard work that he can create anything; sometimes, too, with the precision of those tightrope walkers he loves, who fly in their weightlessness up there thanks to an immense amount of everyday work.

"Chagall has wonderful formulas; he says: 'Stained glass is not so easy. You have to approach it as if you were trying to catch a mouse. Not in a cage... but with your hand. There are no foolproof methods, you either catch it or you don't.''

After Metz, new commissions continued to flow in: there were the windows for the Fraumünster church in Zürich, those for the church of St. Stephen in Mainz, then the Cathedral of Reims; in England he did windows at Tudeley and then in Chichester Cathedral.

From Israel came a commission for stained-glass windows for the synagogue of the medical centre in Jerusalem's Hadassah University (Figs. 151 & 152); and there Chagall had to bow to the law against representing the human figure. It was through a bedazzlement of colours and form — the animals were present, however — that he told the story of the Tribes of Israel.

The United Nations wished to render homage to Dag Hammarskjöld, and this homage took the form of the window entitled *Peace*, inaugurated in 1964. Chagall's last monumental work was the set of stained-glass windows for the chapel of Le Saillant, in Corrèze.

Ceramics and sculpture

It was through ceramics that Chagall came to sculpture. Traditionally the region of Vallauris is a Mecca for potters (Figs. 142, 143 & 144). But just after the Second World War creative activity in this material had sunk to a very low level. Then Picasso made his usual tempestuous entrance on the scene and a great passion for truly artistic pottery was born. Superstars never find it easy to live together, and the relations between Chagall and Picasso, mainly on the latter's account, had never been of the best. There is even a story that Chagall one day had the disagreeable surprise of finding a work that he had done finished by Picasso — who had made a false Chagall, simply to annoy him.

As for Chagall's sculpture, not always very three-dimensional, it is in some ways reminiscent of bas-reliefs of the Roman period (Fig. 145), which means that here, too, the artist remained faithful to that simplicity that always characterized him. The themes are biblical and treated with great tenderness. "There is no demiurgic intention in the relationship the artist establishes with his material," writes Sylvie Forestier, the new curator of the Musée national Message Biblique. The marble and the stone seem to respond to the offer that will give them life. The slight incision of the carving raises as though from their original clay the prophetic figures of Jacob, David and Abraham, or the grave sweetness of the Blessed Virgin. The light caresses the surfaces, framing in velvety shadows the multiplicity of the planes. The three dimensions sublimate the same work of texture and modulation of the light's intensity which he carries out in his engravings.

Conclusion

Is there a secret in Chagall's work? There does not seem to be. What has he done? He has incessantly painted himself — in his work as a painter, in that struggle that begins afresh each day — as only the great can do. But there are perhaps some "keys" of which the painter himself is not necessarily aware. And here I would like to recall a conversation I had with Charles Sorlier, who said: "There are three pictures he has always spoken of to me: *Don Quixote* (Fig. 133), *The Fall of Icarus* (Fig. 136) and *The Chariot of the Sun* (Fig. 137). For my part, and judging from the way in which Chagall evokes these works, I feel sure that to him they represent his life, his death and his resurrection.''

Biography

Marc Chagall is born in Vitebsk (Byelorussia) on July 7, 1887. For about seven or eight years he attends primary school. On leaving he is sent to the official school of Vitebsk, after which (in 1906) he enters the studio of the painter Jehouda Pen, where he remains only two months. At the same time he serves his apprenticeship as a retoucher with a local photographer. Then he leaves for St. Petersburg, where he works for a photographic retoucher. This is a period of extreme poverty, living in wretched quarters and with hardly enough to eat. To live in St. Petersburg, Jews need a special permit. As this permit is granted to craftsmen, Chagall tries to become a sign painter but fails the final examination. Discovered by the lawyer and art patron Goldberg, Chagall enters the latter's household in the guise of a servant (which enables him to obtain his residence permit). He enters the School founded by the Imperial Society for the Protection of Fine Arts. His work soon attracts attention and the director of the School, Nicolas Roerich, succeeds in getting him a deferment of his military service. His work is finally rewarded by a scholarship worth fifteen roubles a month for a year, beginning in September 1907. He leaves the School in July 1908.

1908. After leaving the Imperial School he works for some months in a private school under the direction of the painter Saidenberg. Then Chagall meets Vivaner, a member of the Duma and a very influential man. Towards the end of this year Chagall goes with a note of recommendation to see Bakst, then director of the Swanseva School (more liberal and modern in spirit than any of the others), who accepts the young painter as a pupil and introduces him to a new concept of art.

1909. He continues his studies with Bakst and sometimes visits his family in Vitebsk, where he makes the acquaintance of Bella Rosenfeld, his future wife, whom he is not to marry until 1915, after his first stay in Paris.

1910. He continues his studies at the Swanseva School, where an exhibition of works by the students is held from April 20 to May 9. This exhibition amounts to a manifesto in favour of the new art. Chagall exhibits *The Wedding, The Dead Man* and *Peasant Eating* (a work now lost).

Thanks to a grant offered him by his patron, Vivaner, he leaves St. Petersburg for Paris, where he first lives in a studio at No. 18 in the impasse du Maine (now the impasse Bourdelle). He attends several academies: La Palette and La Grande Chaumière, among others.

1911-1912. During the winter of 1911-1912, or the spring of 1912, Chagall moves into a studio in the Ruche, a haven for artists and poets from all over the world, among them Léger, Laurens, Archipenko, Modigliani and Soutine.

There he paints his first great masterpieces: *To Russia, to Donkeys and to the Others, The Carter Saint, I and the Village, Homage to Apollinaire.* He becomes friendly with Blaise Cendrars, who speaks Russian and who, in 1913, is to dedicate his fourth *Poème élastique* to Chagall. He also meets the poets Max Jacob, André Salmon and Guillaume Apollinaire.

1912. He exhibits three canvases at the Salon des Indépendants and also shows at the Salon d'Automne; *Golgotha* is one of the three works he presents at the latter exhibition.

Through Guillaume Apollinaire he meets Herwarth Walden, a great art dealer and protector of the arts.

During one of his first visits to Chagall's studio in the Ruche, Apollinaire cries, "Supernatural!" on seeing the artist's works.

1913. At the Salon des Indépendants he exhibits the large-scale *Birth* and *Adam and Eve.*

At the Salon des Indépendants of Amsterdam he exhibits three pictures, *Maternity, The Painter and His Fiancée* and *A Musician,* which are acquired for the Regnault Collection.

1914. At the Salon des Indépendants he shows *The Fiddler* and *Self-Portrait with Seven Fingers.*

In June and July he has his first one-man show, held at the Galerie Der Sturm in Berlin. On June 15, after the vernissage, he takes the train for Russia. His intention is to make only a brief stay in Vitebsk, but the outbreak of war prevents him from returning to Paris.

1915. Attempts unsuccessfully to get back to Paris.

Marries Bella Rosenfeld in Vitebsk on July 25.

Is employed in a war economy office in Petrograd, this work being accepted in lieu of military service.

Meets some of the great Russian poets: Aleksandr Blok, Essenine, Mayakovsky and Pasternak.

Exhibits twenty-five of his 1914 works at the official Moscow Art Exhibition and forty-five pictures painted in 1914 and 1915 at another group show.

1916. Birth of his daughter Ida.

Exhibits sixty-three pictures painted in 1914 and 1915 in an exhibition entitled "Contemporary Russian Art" at the Dobitchine Gallery.

In November, forty-five of his works are exhibited at the gallery called "The Knave of Diamonds" in Moscow.

1917. He exhibits seventy-four works at the Dobitchine Gallery in Petrograd. In the spring he has another show at the same gallery, with seven pictures under the title *Studies of Summer.*

The October Revolution is successful. It is then decided to set up a Ministry of Cultural Affairs headed by three men: Mayakovsky for poetry, Meyerhold for the theatre and Chagall for the fine arts. His wife, Bella, advises him strongly to refuse this appointment. They return to Vitebsk, where they stay with Bella's parents, the Rosenfelds.

1918. First monograph on his work, by the critics Efross and Tugenhold. In August, Lunacharsky (an acquaintance of Chagall's in Paris and now People's Commissioner for Education and Culture) gives his consent to the opening of a School of Fine Arts in Vitebsk. Chagall is appointed a Commissioner for Fine Arts and becomes the director of the School.

He is given an individual room in an exhibition at the Winter Palace in Leningrad. The State buys twelve of his works at very low prices.

1919. Inauguration of the Academy in Vitebsk on January 28. Among the teachers are Jean Pougny, Lissitsky, Malevich and Pen (Chagall's first teacher of painting).

Chagall and Malevich soon fall out, as regards both their human relationships and their conceptions of art.

Chagall makes many trips to Moscow in an attempt to obtain subsidies from the Ministry. Returning from one such visit, he finds the inscription "Free Academy" over the door replaced by "Suprematist Academy," Malevich and Lissitsky having taken advantage of his absence to impose their ideas. Chagall tenders his resignation. His supporters finally persuade him, against his will, to withdraw it and he returns to Vitebsk, but he leaves it definitively in May 1920 to establish himself in Moscow.

1920. He does several sets for the theatre: Gogol's *The Government Inspector,* Synge's *The Playboy of the Western World,* Scholem Aleichem's *The Miniatures,* etc.

He meets Alexis Granowsky, director of the Kamerny Jewish Theatre in Moscow, for whom he does some large paintings: *Introduction to Jewish Art Theatre, Literature, Theatre, Dance, Music, The Marriage Table.*

1921. Throughout almost the whole of this year he teaches drawing at the Malakhova and 3rd International colonies for war orphans.

He begins to write his autobiography, "My life."

1922. During the summer Chagall is given a chance to leave Russia.

The poet Jurgis Baltzusaitis, at the time Lithuanian Ambassador to Moscow, permits him to send some canvases to Kaunas.

After a brief stay in Kaunas, Chagall takes his pictures with him to Berlin, where Bella and their daughter Ida manage to join him.

1923. Chagall, with his wife and their daughter, stays in Germany from the summer of 1922 until the autumn of 1923. His first concern is to find Walden, with whom he left a great many canvases eight years earlier. But he only succeeds in recovering three pictures, *To Russia, to Donkeys and to the Others, I and the Village* and *The Poet*, together with ten gouaches.

In Berlin he does twenty engravings for Cassirer on the theme of *Ma vie*, as well as a few lithographs, his first works in this technique.

The works left by Chagall at his studio in the Ruche have been dispersed. Some of them have been appropriated by Blaise Cendrars, who has sold them. Ambroise Vollard (the promoter of Cézanne and Van Gogh, among others) notices some works by Chagall one day at the house of the art critic Coquiot. At this time Coquiot believes that the painter disappeared during the Russian Revolution and for any further information he refers Vollard to Blaise Cendrars, who immediately sends a telegram to his friend, saying: "Come back; you are famous and Vollard is expecting you...." In August 1923 Chagall applies for a visa to enter France and on September 1 he returns to Paris.

At their first meeting Vollard asks Chagall to do the illustrations for an edition of *General Durakine*. But the painter, who is a great admirer of Gogol, prefers to illustrate *Dead Souls*. Vollard declares himself to be enchanted with the book, but he does not publish it. *Dead Souls* is not to appear until 1948, published by Tériade. Chagall is later to illustrate two other works for Vollard: *The Bible* and La Fontaine's *Fables*.

1924. He moves into a studio at No. 101 in the avenue d'Orléans.

In the circles he usually frequents, Chagall meets Sonia and Robert Delaunay, Marcoussis, Juan Gris.

The most important event of the moment is the birth of Surrealism. Max Ernst and Éluard invite him to join their group, but Chagall refuses. From then on the Surrealists, as André Breton tells us, suspect him of "mysticism."

André Breton is to revise this judgment in 1941, when he writes: "His total lyrical explosion dates from 1911. It is at that moment that metaphor, with him alone, makes its triumphant entrance into modern painting. To consummate the subversion of spatial planes, prepared long before by Rimbaud, and at the same time to free the object from the laws of gravity and to demolish the barrier of elements and signs, in Chagall this metaphor reveals itself from the start as a plastic support in the hypnagogic image and in the eidetic (or aesthetic) image, which should not be described until later, with all the characters that Chagall has succeeded in attributing to it. There has been nothing so decidedly magical as this work, in which the prismatic colours take up and transform the torment of our age, reserving the old naiveté for the expression of everything in nature that proclaims the pleasure principle: flowers and expressions of love."

Retrospective exhibition at the Galerie Barbazange-Hodebert, where he makes the acquaintance of André Malraux, who is henceforward to play an important role in his career.

1925. Florent Fels, who has a country house near Septeuil, introduces him to the countryside between the Seine and the Oise.

Chagall rents two rooms in the house of the local constable at Montchauvet, near Mantes. He and his family spend some weeks there from time to time. While there he concentrates particularly on the task of finishing the plates for *Dead Souls*.

1926. Invited by Ambroise Vollard to illustrate La Fontaine's *Fables*, Chagall begins to paint the hundred large gouaches that are the basis of this work, which is to be done in copperplate engraving.

In the spring he spends some time at Mourillon, near Toulon, and then in Nice, where the vegetation and the light are a revelation to him. From this first contact stems his later passion for the Côte d'Azur.

He then spends some months in the Auvergne, mostly at the Lac Chambon, where he works on the gouaches for the *Fables*.

He does fifteen etchings for *Les Sept péchés capitaux* and five etchings for Marcel Arland's *Maternité*.

He rents a house in Boulogne-sur-Seine and becomes acquainted with the publisher Tériade, as also with Maillol, Rouault, Vlaminck and Bonnard.

First exhibition in America, at the Reinhart Galleries in New York.

1927. Again at Vollard's request, he returns to the theme of the circus and does nineteen large gouaches.

He signs a contract with Bernheim "the younger".

In the summer he returns to the Auvergne, where his wife takes the cure at Chatelguyon. He also has a short holiday near Saint-Jean-de-Luz.

In the autumn he goes on a motoring trip with Robert Delaunay to Limoux, near Carcassonne, in order to meet Joseph Delteil, and then to Collioure to visit Maillol. He also becomes acquainted with Jean Paulhan.

1928. He visits Savoie with the family. In the summer he goes alone to Céret.

He starts work on the engravings for La Fontaine's *Fables*. Translation into French of his autobiography, *Ma vie*, by Bella Chagall with the assistance of Ludmilla Gaussel and some advice from Jean Paulhan.

1929. Visit to Céret, accompanied by Bella, in the autumn.

A winter stay in Savoie.

He buys a house near the Porte d'Auteuil.

1930. In the spring he spends a few days in Berlin for the exhibition of the gouaches for the *Fables* at the Galerie Flechtheim.

Holiday with the family at Nesle-la-Vallée, not far from Nantes.

During the summer and autumn he spends some weeks first on the Mediterranean coast and then at Peïra-Cava, in the Alpes-Maritimes. Vollard commissions Chagall to do illustrations for *The Bible*.

The painter begins this work by doing a series of large gouaches. These works are now housed in the Musée national Message Biblique Marc Chagall in Nice.

1931. With his wife and daughter, he spends the months from February to April in Palestine on the invitation of Dizengoff, one of the great pioneers of Israel, founder and mayor of Tel Aviv.

Before this stay Chagall visits Alexandria, Cairo and the Pyramids. He works for some time in Tel Aviv, Jerusalem and, later, Safed.

The engraving of the hundred and five etchings for *The Bible* is to take a long time. Between 1931 and Vollard's death, shortly before the war, Chagall finishes sixty-six of the plates. He resumes work on *The Bible* in 1952. The work is finished in 1956 and published by Tériade.

Publication (by Stock) of *Ma vie*, translated into French by Bella Chagall.

1932. Visit to Holland.

He spends the autumn at Cap-Féret.

1933. He visits Italy, Holland and England, and then Spain, where he is much distressed by the political events. He studies Rembrandt and El Greco.

Retrospective exhibition at the Museum of Basel.

In Mannheim the Nazis burn some of Chagall's works in public.

1934. In the month of August he visits Spain again.

1935. After visiting Poland for the inauguration of the French Institute in Vilnius, he spends the summer with his family in Vézelay.

1936. He moves to a new studio in Paris, at No. 4 in the Villa Eugène-Manuel.

Chagall spends the summer at Oye-et-Pallet in the Jura.

The winter is spent first at Morzine, in Haute-Savoie, then at Villars-Colmar, in the Vosges, where he remains until early in 1937.

1937. In the spring he spends some time at Villeneuve-lès-Avignon, after which he leaves for Italy.

In Tuscany he does fifteen of the engravings for *The Bible*.

The Nazi régime orders the removal of all the painter's works in German museums.

Chagall adopts French nationality.

He makes some new friends: Jacques Maritain, Jules Supervielle, Marcel Arland, Eugène Dabit and René Schwob.

1938. He and his wife spend some months at Villentroy, in the Indre-et-Loire.

Exhibition at the Palais des Beaux-Arts in Brussels.

1939. Just before the declaration of war, Chagall and his family take refuge in Saint-Dye-sur-Loire, where he has already taken all the canvases in his Paris studio (removed from their stretchers) by taxi.

Chagall is awarded the Carnegie Foundation Prize.

1940. In January he takes some of his works to Paris for an exhibition organized by Yvonne Zervos on the occasion of the opening of the Galerie Mai.

At this time he frequently meets Zervos and Picasso.

On the advice of André Lhote, Chagall decides to retreat to the free zone, south of the Loire. At Easter he and his wife leave for Gordes, a little village in the Lubéron.

On May 10, the day on which the Germans invade Belgium, Chagall buys an old, disused schoolhouse, with classrooms ideal for use as studios.

They are to spend almost a year in Gordes.

1941. Towards the end of 1940, Chagall is visited by Varian Fry (director of the Emergency Rescue Committee) and Harry Bingham (consul general of the United States in Marseilles), with an invitation to the States.

After much hesitation, Chagall and his family go to Marseilles in April to prepare for their departure. On June 23 (the day of the German invasion of Russia), they land in New York, where Chagall finds some old friends — Léger, Bernanos, Masson, Maritain, Mondrian, André Breton — and meets Pierre Matisse, who becomes his dealer, before the definitive accolade of the 1946 exhibition at the Museum of Modern Art in New York.

In November he has an exhibition at the Pierre Matisse Gallery of works done between 1910 and 1941: *The Wedding* (1910), *To Russia, to Donkeys and to the Others* (1911), *Anywhere Out of the World* (1916), *Time has No Shore* (1930-1939), *The Newly-Weds of the Eiffel Tower* (1938).

1942. During the summer Chagall goes to Mexico to do the décor and costumes for the ballet *Aleko*, to music by Tchaikovsky, on the theme of Pushkin's *Tziganes*.

1943. He spends some time with his family at Cranberry Lake.

The news from war-torn Europe saddens Chagall enormously and he expresses his distress in many works, among them *War*, *Obsession* and *The Yellow Crucifixion*.

1944. He paints a number of pictures during a second stay at Cranberry Lake.

Chagall and Bella intend to return to New York around the beginning of September. A few days later Bella falls ill and is taken urgently to the local hospital where, for lack of proper care, she dies within thirty-six hours.

Overwhelmed by grief, for nearly ten months Chagall is unable to work.

1945. In the spring Chagall begins to paint again. He takes a large picture entitled *Harlequins* (a sketch for which is still extant), cuts it in two and on the left-hand side, using the existing composition, paints *Around Her*. Then on the right-hand side of the original canvas he paints *The Lights of the Wedding*.

During the summer he works at Krumville, on the shore of Lake Beaver in Ulster County, and later at Sag Harbor, on Long Island.

For the American Ballet Theatre he does the décor and costumes for a new production of Stravinsky's *The Firebird*.

1946. During the winter of 1945-46 he buys a little house at High Falls, in the north-east of New York State.

From April to June the Museum of Modern Art in New York holds a great retrospective exhibition, presenting over forty years of his painting. Chagall, however, is impatient to return to Europe; in May he goes to Paris for a three months' stay.

In the autumn he returns to High Falls.

He does his first lithographs in colour, for the illustrations to an edition of *The Thousand and One Nights*.

1947. He goes to Paris for the inauguration of a retrospective exhibition organized on the occasion of the reopening of the Musée d'Art moderne after the German occupation.

A series of retrospective exhibitions in Europe: the Stedelijk Museum in Amsterdam, the Tate Gallery, the Kunsthaus in Zürich and the Kunsthalle in Bern.

1948. He returns to France for good and settles in Orgeval.

He makes the acquaintance of Aimé Maeght, who becomes his dealer in France.

He is given a room to himself in the French Pavilion at the 35th Venice Biennale, at which he is awarded the Grand Prix for engraving.

Publication of *Dead Souls* by Tériade.

1949. From January to May he stays at Saint-Jean-Cap-Ferrat. He does some mural paintings for the foyer of the Watergate Theatre in London.

After a short stay in Orgeval he returns to the Midi and stays in the village of Saint-Jeannet. Then he buys a house in Vence.

He does his first ceramics in Antibes and later at the Madoura pottery in Vallauris.

1950. In the spring he moves into his house in Vence and often meets Henri Matisse and Picasso, who are living in Nice and Vallauris respectively.

In the atelier of Fernand Mourlot he does his first lithographic poster, on the occasion of an exhibition at the Galerie Maeght. From now on, Chagall is to do all his lithographs in this famous atelier, where he becomes friendly with the master lithographer Charles Sorlier, who is to remain one of his most loyal collaborators.

Retrospective exhibition at the Kunsthaus in Munich.

1951. He visits Israel for the opening of an exhibition in Jerusalem.

During the summer he makes a short stay in Gordes, in the house where he lived in 1940 and 1941, and then in Dramont, a little seaside village near Saint-Raphaël.

1952. He meets Valentina (Vava) Brodsky, whom he marries at Clairefontaine, near Rambouillet, on July 12. This marriage is to give new energy to the artist, by now rightly regarded as one of the greatest painters of the 20th century. With the encouragement of his wife he begins a new stage in his career which is to include, among other achievements, the admirable works that constitute the *Biblical Message* and the great decorative ensembles, among them the ceiling of the Paris Opera House and the stained-glass windows for the cathedrals of Reims and Metz.

In June he visits the cathedral of Chartres to study the conception and technique of its medieval stained-glass windows.

The publisher Tériade commissions Chagall to do some original lithographs in colour as illustrations to *Daphnis and Chloe*, by Longus.

During the summer Chagall and Vava make a journey to Greece, visiting Delphi and Athens, and staying for some time on the island of Poros.

He visits Rome, Naples and Capri.

Publication, by Tériade, of the *Fables* of La Fontaine.

1953. He visits Turin for the opening of a great retrospective exhibition at the Palazzo Madama.

First preparatory gouaches for the illustrations to *Daphnis and Chloe*.

1954. During the autumn, accompanied by his wife, he visits Greece again and then Ravenna, Florence and, above all, Venice, where he delightedly renews his acquaintance with the works of Titian and Tintoretto.

1955. He begins to work on the series of paintings constituting the *Biblical Message*, which he is to finish in 1966.

1956. Exhibition at the Kunsthalle in Basel and then in Bern. Publication of *The Bible*.

1957. Retrospective exhibition of his work in engraving at the Bibliothèque Nationale in Paris.

He does his first mural mosaic: *The Blue Cock*.

He finishes the decoration of the baptistery of Notre-Dame-de-Toute-Grâce, on the Plateau d'Assy. In order to underline his refusal of all confessional limitations, the artist has inscribed at the base of the ceramic: "In the name of the freedom of all religions."

He starts work at the Mourlot atelier on the illustrations to *Daphnis and Chloe* commissioned by the publisher Tériade.

1958. In February he visits Chicago, where he gives a lecture.

He makes the acquaintance of Charles Marq, master glass-worker and director of the Jacques Simon glassworks in Reims, who becomes a great friend.

During the autumn he paints some gouaches at Mies, on the shore of Lake Geneva.

He does the décor and costumes for a production of Maurice Ravel's *Daphnis and Chloe* at the Paris Opera House.

Models of the stained-glass windows for Metz Cathedral.

1959. He visits Glasgow to receive an honorary doctorate from the University.

He is appointed an honorary member of the American Academy of Arts and Letters.

Retrospective exhibition at the Musée des Arts décoratifs of the Louvre in Paris.

Stained-glass compositions for the second window in the north apse of Metz Cathedral: *Moses Receiving the Tables of the Law, David and Bathsheba, Jeremiah and the Exodus of the Jewish People.*

1960. Early in the year he paints some gouaches in Sills Maria (Switzerland). He does the model of the stained-glass windows for the synagogue of the Hadassah Medical Center in Jerusalem and receives an honorary doctorate from Brandeis University (USA).

He is awarded, jointly with Kokoschka, the Erasmus Prize of the European Cultural Foundation in Copenhagen.

First exhibition of stained glass, intended for Metz Cathedral, at the Museum of Reims.

1961. Exhibition of *The Twelve Tribes of Israel*, in stained glass, at the Musée des Arts décoratifs in Paris.

The same exhibition is presented at the Museum of Modern Art in New York from November 1961 to January 1962.

1962. In February he visits Jerusalem for the inauguration of *The Twelve Tribes of Israel.*

Exhibition entitled "Chagall and the Bible" at the Musée Rath in Geneva.

Stained-glass compositions for the first window in the north apse of Metz Cathedral: *The Sacrifice of Isaac, Jacob Wrestling with the Angel, Jacob's Dream, Moses Before the Burning Bush.*

1963. Retrospective exhibition at the National Museum in Tokyo and the National Museum in Kyoto.

Visit to Washington.

On the invitation of General de Gaulle and André Malraux, Chagall starts work on the model of the new ceiling for the auditorium of the Paris Opera House.

Stained-glass compositions for the window of the north transept in the east front of Metz Cathedral: *The Creation of Man, The Creation of Eve, Eve and the Serpent, Adam and Eve Driven Out of the Earthly Paradise.*

1964. In May an exhibition of the stained glass for Metz Cathedral at the Musée des Beaux-Arts in Rouen. He does another work in stained glass, *The Good Samaritan*, as a memorial to John D. Rockefeller Jr., for the chapel of Pocantico Hills, in New York State.

He visits New York for the unveiling, on September 17, of the stained-glass window entitled *Peace*, placed in the United Nations building as a memorial to Dag Hammarskjöld.

1965. He receives an honorary doctorate from the University of Notre-Dame (USA).

He begins the preliminary studies for the décor and costumes for a production of Mozart's *The Magic Flute* at the Metropolitan Opera, New York.

1966. He leaves Vence and moves into a house in Saint-Paul-de-Vence (Alpes-Maritimes).

He works on the two large mural decorations intended for the Metropolitan Opera of New York: *The Sources of Music* and *The Triumph of Music.*

He does eight stained-glass windows, on the theme of *The Prophets*, for the chapel of Pocantico Hills, in New York State.

1967. Inauguration of the New Metropolitan Opera of New York and first performance of Mozart's *The Magic Flute* with décor and costumes by Marc Chagall, on February 19.

Retrospective exhibition in Zürich and Cologne in honour of the painter's eightieth birthday.

From June to October, exhibition of the *Biblical Message*, donated by Marc and Vava Chagall, at the Louvre, Paris.

Exhibition entitled "Homage to Chagall," organized by the Maeght Foundation, in Saint-Paul-de-Vence.

Publication of *Le Cirque*, with text and thirty-eight lithographs by Marc Chagall.

1968. Visit to Washington.

At the request of his friend Louis Trotabas, Dean of the University of Law and Economic Science in Nice, Chagall does a huge mosaic (three metres by eleven) on the theme of *Ulysses.*

Stained-glass windows for the triforium in the north transept of Metz Cathedral.

1969. Laying of the foundation stone of the Musée national Message Biblique Marc Chagall in Nice.

Chagall goes to Jerusalem for the inauguration of the new Parliament on June 18. For this building the artist has created floor mosaics, a mural mosaic entitled *The Wailing Wall* and three large tapestries: *The Prophecy of Isaiah, The Exodus* and *The Entry into Jerusalem.*

From December 1969 to March 1970, retrospective exhibition entitled "Homage to Chagall," at the Grand Palais in Paris.

1970. From January to March, retrospective exhibition of Chagall's work in engraving at the Bibliothèque national in Paris.

Inauguration of the stained-glass windows of the Fraumünster church in Zürich.

1971. In the spring Chagall visits Zürich.

Exhibition of sixty lithographs at the Museum der Bildenden Kunst.

He does a large-scale mural mosaic entitled *Elijah's Chariot* for the Musée national Message Biblique in Nice.

1972. Chagall starts work on a large-scale mosaic, *The Four Seasons*, commissioned by the First National City Bank for the embellishment of a square in Chicago.

Exhibition in October and November at the Museum of Budapest.

He starts work on illustrations of Homer's *Odyssey* for the publishing department of F. Mourlot.

He does the stained-glass compositions entitled *The Creation of the World* for the concert hall of the Musée national Message Biblique in Nice.

1973. In June, on the invitation of Jekaterina Furzewa, the Russian Minister for Culture, Chagall and his wife visit Moscow and Leningrad, where, fifty years after his departure, the painter meets two of his sisters. In the course of this journey Chagall obstinately refuses to visit Vitebsk.

Exhibition organized by the Russian government at the Tretiakov Gallery in Moscow.

On July 7, the painter's birthday, the Musée national Message Biblique Marc Chagall is inaugurated in Nice, in the presence of the artist's friend André Malraux.

1974. Exhibition at the National Gallery in West Berlin.

On June 15, unveiling of the stained-glass windows for the central choir of Reims Cathedral.

From July to September, exhibition of the "Models for the Monumental Works" at the Musée national in Nice.

Chagall visits Chicago, where the whole city is decked with flags to give him a triumphal welcome, for the inauguration of the mosaic of *The Four Seasons.*

He does some engravings in colour for *Celui qui dit les choses sans rien dire*, poems by Louis Aragon.

1975. From March to September he works on lithographic illustrations for Shakespeare's *The Tempest.*

He paints several large canvases: *The Fall of Icarus, Don Quixote, Job, The Prodigal's Return.*

Model of a stained-glass window intended for the chapel of Les Pénitents in Sarrebourg (France).

Publication of *The Odyssey*, illustrated by eighty-two original lithographs.

1976. Inauguration of a mosaic in the Chapelle Sainte-Rosaline-aux-Arcs (Var).

He does some copperplate engravings as illustrations to articles by André Malraux.

Publication, by Raymond Lévy, of Shakespeare's *The Tempest* and, by Éditions Maeght, of Louis Aragon's *Celui qui dit les choses sans rien dire.*

1977. On January 1, Chagall is awarded the Grand Cross of the Legion of Honour.

Visit to Italy.

He works on the models of the stained-glass windows intended for the Art Institute of Chicago.

Opening on July 9, an exhibition of his recent biblical paintings at the Musée national in Nice.

On October 17, inauguration by the President of the Republic of an exhibition at the Louvre, Paris.

He visits Israel, where he is declared an honorary citizen of the City of Jerusalem.

Publication, by Éditions Maeght, of André Malraux's *Et sur la terre.*

1978. In June he visits Italy to attend the opening of an exhibition of his works at the Palazzo Pitti in Florence.

In September, unveiling of the stained-glass windows in the church of St. Stephen in Mainz.

In October, unveiling of the stained-glass windows in Chichester Cathedral, England.

He works on copperplate engravings intended to illustrate the Psalms.

1979. He does a second series of stained-glass windows for the church of St. Stephen in Mainz.

Unveiling of the stained-glass windows done for the Art Institute of Chicago.

Exhibition of paintings (1975-78) at the Pierre Matisse Gallery in New York.

Exhibition of the *Psalms of David* at the Galerie Patrick Cramer in Geneva.

1980. From January to June, exhibition of the *Psalms of David* at the Musée national Message Biblique Marc Chagall in Nice.

He paints the lid of a harpsichord presented to the Musée national Message Biblique Marc Chagall by himself, his wife and the American Friends of Chagall's Biblical Message.

Exhibition of engravings and monotypes at the Musée Rath and the Galerie Patrick Cramer in Geneva.

1981. Inaugural concert of the harpsichord presented to the Musée national Message Biblique Marc Chagall.

Retrospective exhibition of engravings at the Galerie Matignon in Paris.

Inauguration of a third series of stained-glass windows in the church of St. Stephen in Mainz.

Exhibition of lithographs at the Galerie Maeght in Paris.

Exhibition of recent paintings at the Galerie Maeght in Zürich.

1982. Finishes the stained-glass windows for the chapel of Le Saillant.

From September to December, retrospective exhibition at the Moderna Museet in Stockholm.

Exhibition of illustrated books at the Galerie Patrick Cramer in Geneva.

Exhibition of paintings at the Pierre Matisse Gallery in New York.

1984. From June to October, exhibition of "The Works on Paper" at the Musée national d'Art moderne in Paris.

From July to October, exhibition of "Stained-Glass Windows and Sculptures: 1957-1984" at the Musée national Message Biblique Marc Chagall in Nice.

1985. On March 28, Chagall dies in his house at Saint-Paul-de-Vence.

Select bibliography

Principal writings and published statements of Marc Chagall

CHAGALL, Marc: *Ma vie* (translated into French by Bella Chagall). Paris, 1931 (reprinted 1972 and 1983).

Quelques impressions sur la peinture française. Lecture given at Mount Holyoke College. *Renaissance*, Vols. II and III. The New York Free School of Higher Studies, New York, 1944-1945.

The Work of the Mind. Lecture given at the University of Chicago. The University of Chicago Press, Chicago, 1947.

Pourquoi sommes-nous devenus si anxieux? Lecture given at the University of Chicago. Bridges of Human Understanding, New York, 1964.

SCHNEIDER, Pierre: *Propos de Marc Chagall.* Les Dialogues du Louvre, Paris, 1967.

CHAGALL, Marc: *Le Cirque.* Éditions Revue Verve, Paris, 1967.

CHAGALL, Marc: *Poèmes 1909-1972.* Cramer, Geneva, 1975.

Principal monographs

APOLLONIO, Umbro: *Chagall.* Alfieri, Milan, 1949.

SCHMALENBACH, Werner: *Chagall.* The Uffici Press, Milan, 1954.

LASSAIGNE, Jacques: *Marc Chagall.* Maeght, Paris, 1957.

MATHEY, François: *Marc Chagall.* Somogy, Paris, 1959.

DAMASE, Jacques: *Chagall.* Marabout Université, Paris, 1963.

MEYER, Franz: *Marc Chagall.* Flammarion, Paris, 1964.

PARINAUD, André: *Chagall.* Bordas, Paris, 1966.

COGNIAT, Raymond: *Chagall.* Flammarion, Paris, 1968.

LASSAIGNE, Jacques: *Chagall: dessins inédits.* Skira, Paris, 1968.

BIDERMANAS, Izis & McCULLEN, Roy: *Le Monde de Marc Chagall.* Gallimard, Paris, 1969.

Hommage à Marc Chagall. Special issue of the review *XXᵉ Siècle*. Paris, 1969.

BUCCI, Mario: *Marc Chagall.* Sansoni, Florence, 1970.

HAFTMANN, Werner: *Marc Chagall.* DuMont Schauberg, Cologne, 1972.

MALRAUX, André & SORLIER, Charles: *Céramiques et sculptures.* André Sauret, Monte Carlo, 1972.

Chagall monumental. Special issue of the review *XXᵉ Siècle*. Paris, 1973.

PIEYRE de MANDIARGUES, André: *Chagall.* Maeght, Paris, 1974.

MARQ, Charles & PROVOYEUR, Pierre: *Catalogue de l'œuvre monumental.* Éditions de la Réunion des Musées Nationaux, Paris, 1974.

HAFTMANN, Werner: *Chagall.* Chèvre, Paris, 1975.

ALEXANDER, Sidney: *Marc Chagall: a Biography.* G.P. Putnam's Sons, New York, 1978.

SCHMALENBACH, Werner & SORLIER, Charles: *Marc Chagall.* Draeger, Paris, 1979.

HAFTMANN, Werner: *Marc Chagall.* Cercle d'Art, Paris, 1983.

VERDET, André & WYMAN, Bill: *Chagall méditerranéen.* Daniel Lelong, Paris, 1983.

Books on Chagall's work in engraving

CAIN, Julien, MOURLOT, Fernand & SORLIER, Charles: *Chagall lithographe: 1927-1973.* 4 Vols. André Sauret, Monte Carlo, 1957-1973.

MEYER, Franz: *Marc Chagall: l'œuvre gravé.* Gerd Hatje, Stuttgart, 1957.

KORNFELD, E.W.: *Chagall: cuivres et bois gravés.* Kornfeld und Klipstein, Bern, 1970.

ADHÉMAR, Jean, SENGHOR, Léopold S. & SORLIER, Charles: *Les Affiches de Marc Chagall.* Draeger, Paris, 1975.

LEYMARIE, Jean: *Marc Chagall: monotypes 1961-1975.* 2 Vols. Cramer, Geneva, 1966-1976.

CHAGALL, Marc, MALRAUX, André, MARTEAU, Robert & SORLIER, Charles: *Marc Chagall et Ambroise Vollard.* Galerie Matignon, Paris, 1981.

Books on Chagall's work for the theatre

ARAGON, Louis & LASSAIGNE, Jacques: *Le Plafond de l'Opéra de Paris.* André Sauret, Monte Carlo, 1965.

LASSAIGNE, Jacques: *Marc Chagall: dessins et aquarelles pour le ballet.* Éditions XXᵉ Siècle, Paris, 1969.

GENAUER, Emily: *Chagall at the Met.* Metropolitan Opera Association Inc. and Tudor Publishing Company, New York, 1971.

Books on Chagall's work in stained glass

LEYMARIE, Jean: *Marc Chagall: vitraux pour Jérusalem.* André Sauret, Monte Carlo, 1969.

VOGELSÄNGER de ROCHE, Irmgard: *Marc Chagall: vitraux pour Zürich.* Orell Fussli, Zürich, 1971.

MARQ, Charles & MARTEAU, Robert: *Les vitraux de Chagall 1957-1970.* A.C. Mazo, Paris, 1972.

Books on the Biblical Message

SCHAPIRO, Meyer & WAHL, Jean: *La Bible.* Editions Revue Verve, Paris, 1956.

BACHELARD, Gaston: *Dessins pour la Bible.* Éditions Revue Verve, Paris, 1960.

BACHELARD, Gaston, CHATELAIN, Jean, MARTEAU, Robert & SCHAPIRO, Meyer: *Le Message Biblique.* E. Mourlot, Paris, 1972.

LEYMARIE, Jean: *Catalogue du Musée national Message Biblique Marc Chagall.* Éditions de la Réunion des Musées Nationaux, Paris, 1973.

AMISHA-MAISELS, Ziva & YESHAYAHU, Israel: *Marc Chagall at the Knesset.* Tudor Publishing Company, New York, 1973.

PROVOYEUR, Pierre: *Chagall, le Message Biblique.* Cercle d'Art, Paris, 1983.

ILLUSTRATIONS

1. *The Kermesse*. 1908.
 Oil on canvas, 68 × 95 cm.
 Pierre Matisse Gallery, New York.

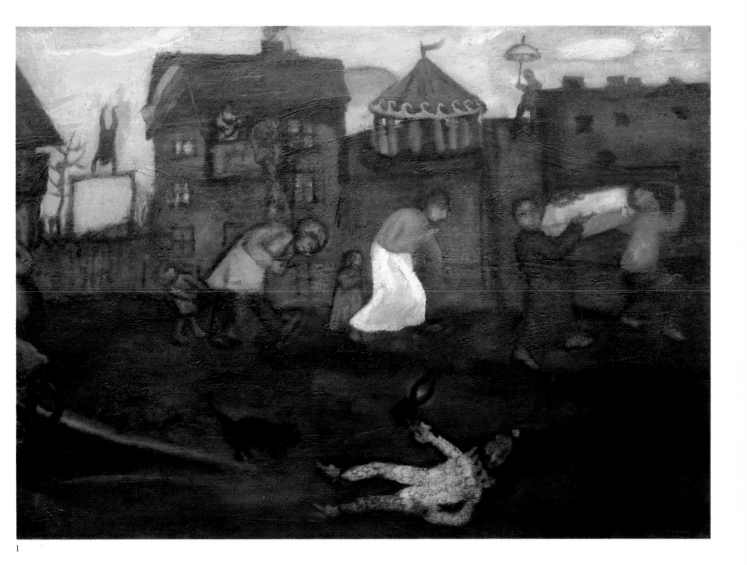

1

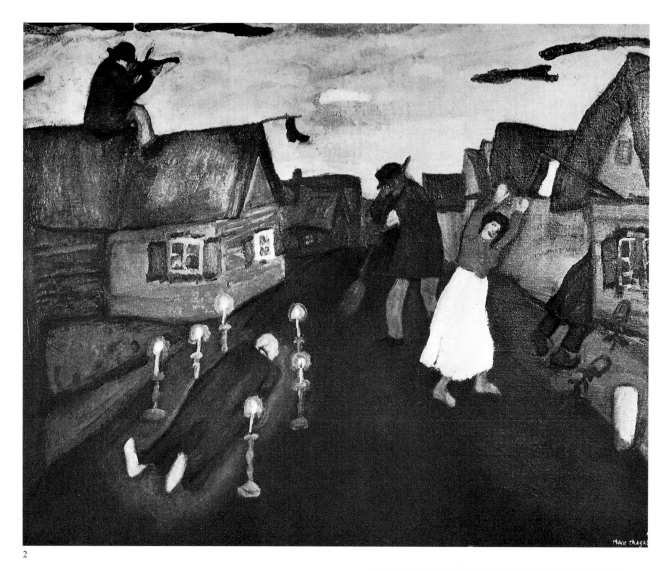

2

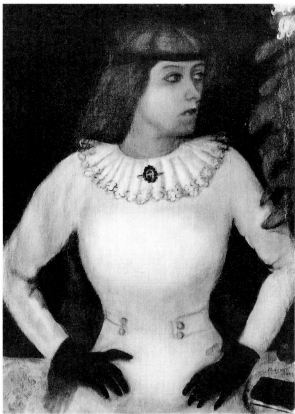

3

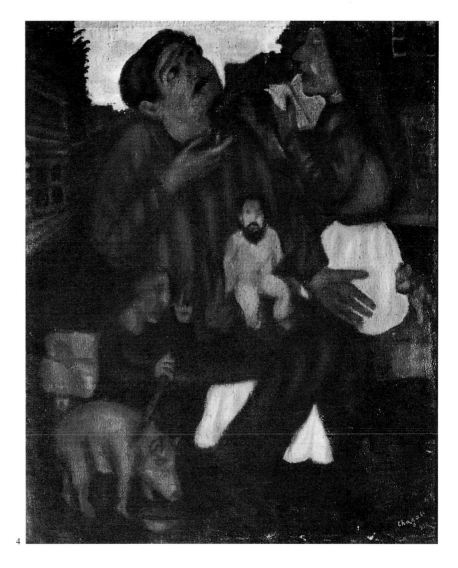

4

5

6

7

8

9

10

6. *View of Vitebsk*. 1909.
 Pencil and gouache on thick beige paper, 38×29 cm.
 Private collection, Paris.

7. *Still Life*. 1911.
 Oil on canvas, 63×78 cm.
 Mr. and Mrs. Eric E. Estorick Collection.

8. *Nude with Comb*. 1911-1912.
 Black ink and gouache on brown paper, 33.5×23.5 cm.
 Private collection, Paris.

9. *Nude with Arm Raised*. 1911.
 Gouache on brown paper, 28.5×19 cm.
 Private collection, Paris.

10. *Cain and Abel*. 1911.
 Gouache on paper, 22×28.5 cm.
 Ida Chagall Collection, Paris.

11. *Self-Portrait with His Parents*. 1911.
 Pen-and-ink drawing, 18×12 cm.
 The artist's collection.

11 и я отец, мати и же ... Париж 1911 год.

12. *I and the Village*. 1911.
 Oil on canvas, 191.2×150.5 cm.
 The Museum of Modern Art, New York. Mrs. Simon Guggenheim Fund.

13. *The Fiddler*. 1911.
 Oil on canvas, 94.5×69.5 cm.
 Kunstsammlung Nordrhein-Westfalen, Düsseldorf.

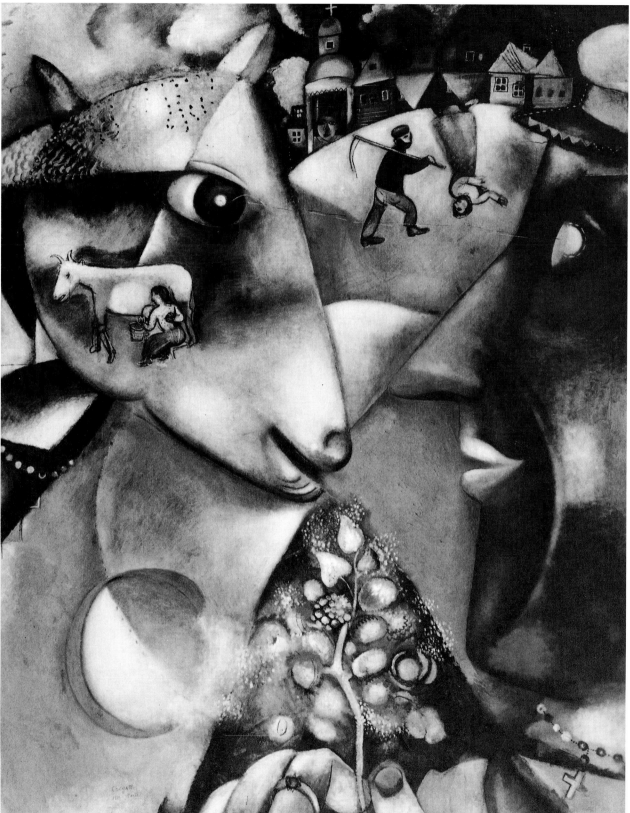

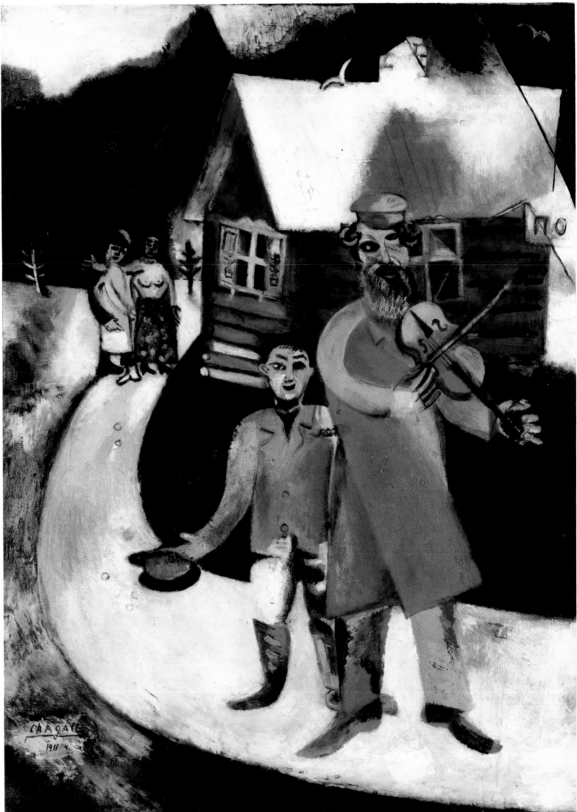

13

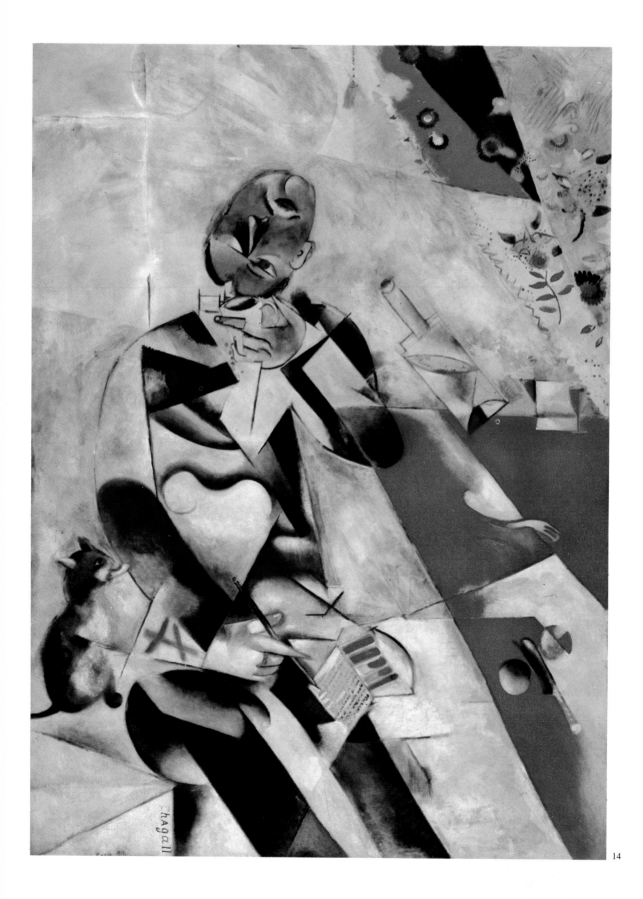

14

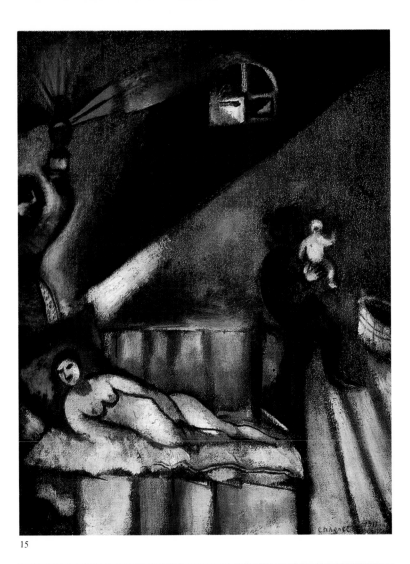

15

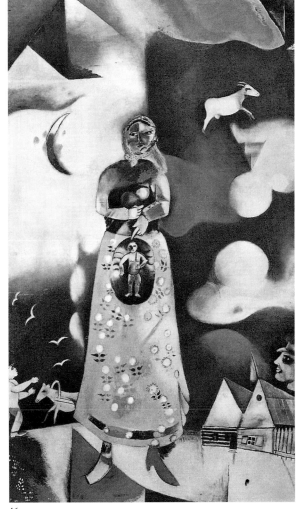

16

17

14. *The Poet (Half Past Three)*. 1911.
Oil on canvas, 196 × 145 cm.
Philadelphia Museum of Art. The Louise and Walter
Arensberg Collection.

15. *The Birth*. 1911.
Oil on canvas, 46 × 36 cm.
Private collection, Paris.

16. *The Pregnant Woman*. 1912-1913.
Oil on canvas, 194 × 115 cm.
Stedelijk Museum, Amsterdam.

17. *Head with Halo*. 1911.
Gouache on brown paper, mounted on canvas,
20.5 × 18.5 cm.
Private collection, Paris.

18. *To Russia, to Donkeys and to the Others.* 1911-1912.
Oil on canvas, 156 × 122 cm.
Musée national d'Art moderne, Centre Georges Pompidou, Paris.

19. *Homage to Apollinaire.* 1911-1912.
Oil on canvas, 209 × 198 cm.
Van Abbemuseum, Eindhoven.

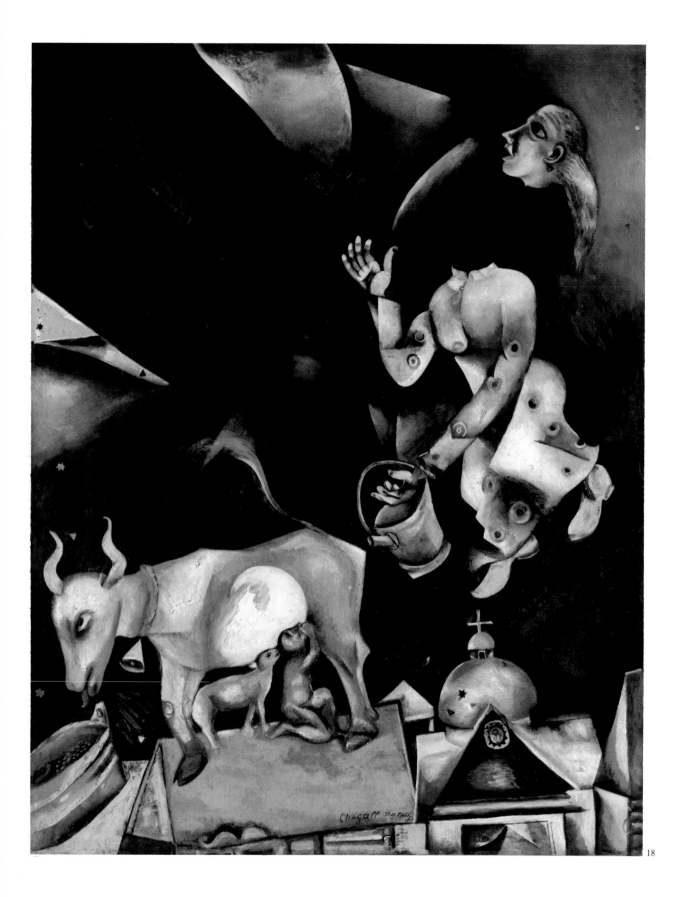

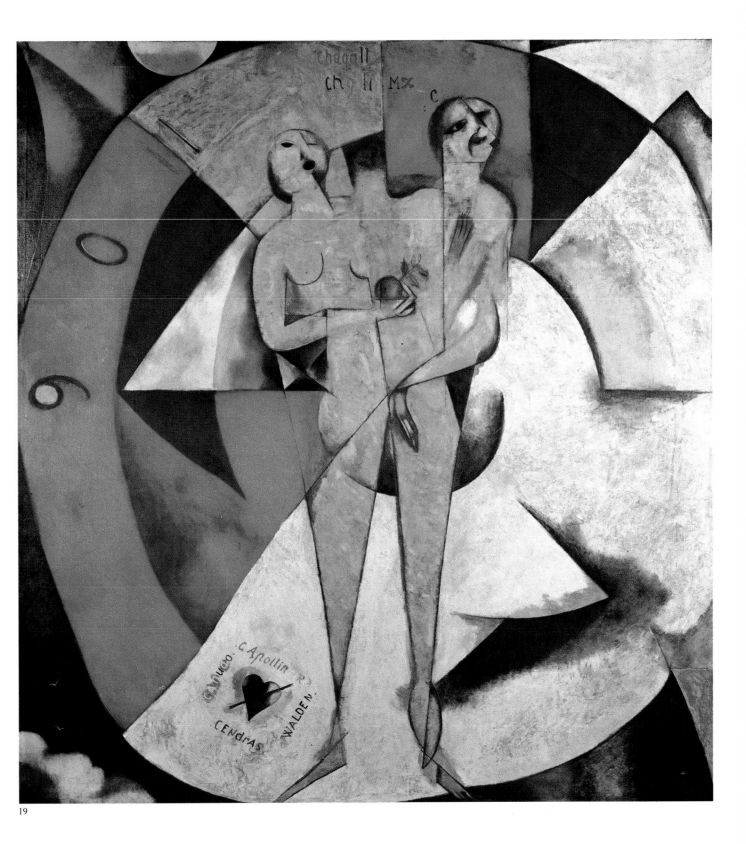

20. *Golgotha*. 1912.
 Oil on canvas, 174×191 cm.
 The Museum of Modern Art, New York. Lillie P. Bliss Bequest.

21. *The Soldier Drinks*. 1912.
 Oil on canvas, 110.3×95 cm.
 The Solomon R. Guggenheim Museum, New York.

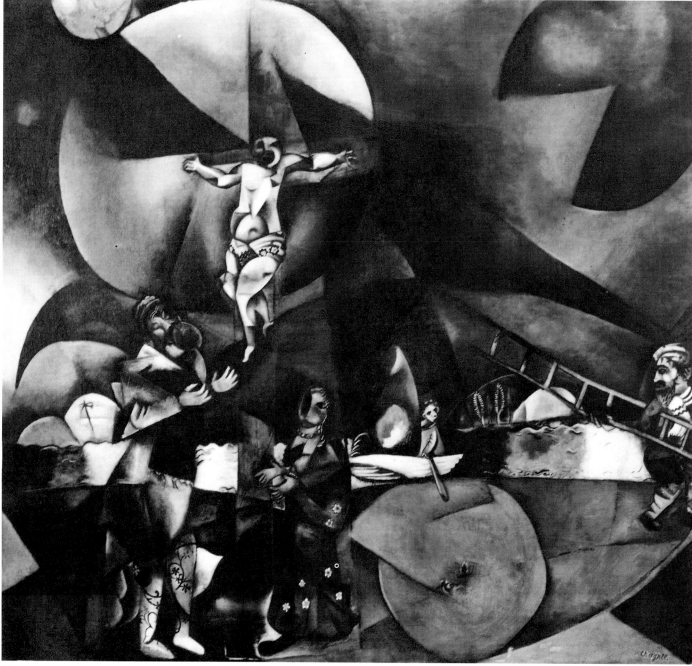

21

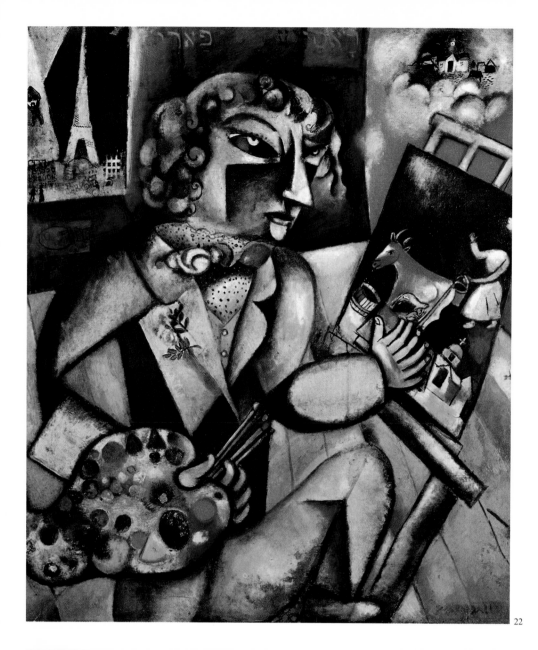

22

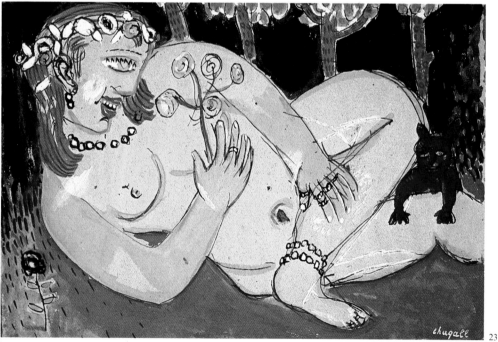

23

22. *Self-Portrait with Seven Fingers.*
1912-1913.
Oil on canvas, 128 × 107 cm.
Stedelijk Museum, Amsterdam.

23. *The Odalisque.* 1913-1914.
Black ink and watercolour
on brown paper, 20.2 × 29 cm.
E.W. Kornfeld Collection, Bern.

24. *My Mother.* 1914.
Pencil on paper, 22 × 20 cm.
The artist's collection.

25. *The Jew with the Stick.* 1913.
Pen-and-ink drawing, 25 × 13 cm.
Private collection, Paris.

26. *Peasant Eating.* 1913-1914.
Pen-and-ink drawing, 28.5 × 22 cm.
Private collection.

27. *The Old Man.* 1914.
Pen-and-ink drawing, 25 × 16 cm.
The artist's collection.

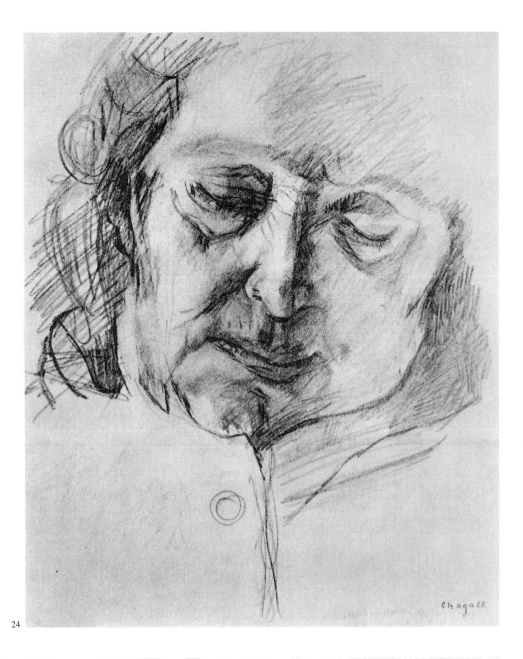

24

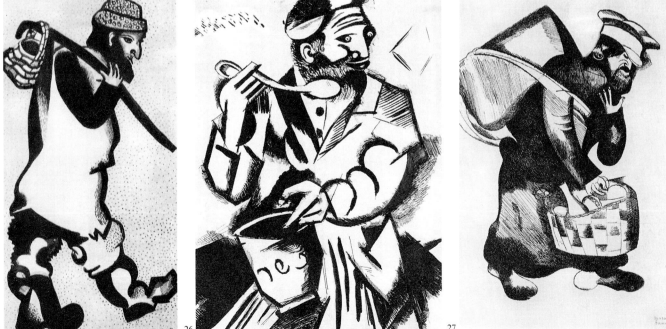

25

26

27

28. *Over Vitebsk*. 1914.
 Oil on reinforced cardboard, 73 × 92.5 cm.
 Art Gallery of Ontario, Toronto. Sam and Ayala Zacks Donation

29. *Feast Day (The Rabbi with a Lemon)*. 1914.
 Oil on cardboard, 100 × 80.5 cm.
 Kunstsammlung Nordrhein-Westfalen, Düsseldorf.

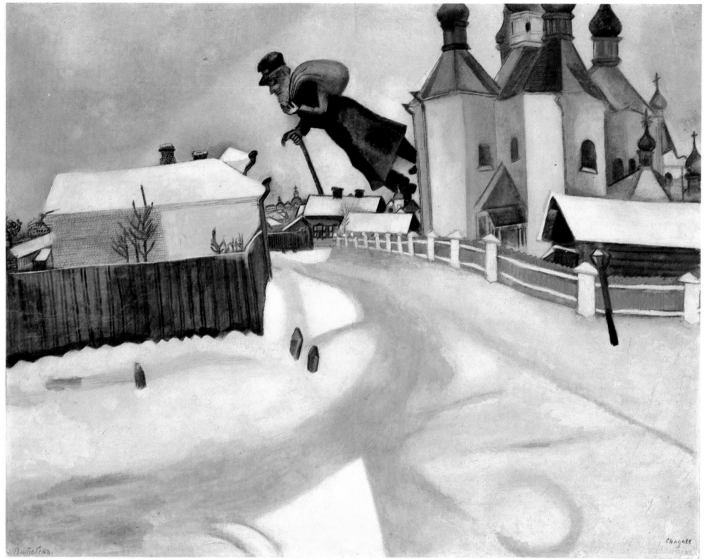

28

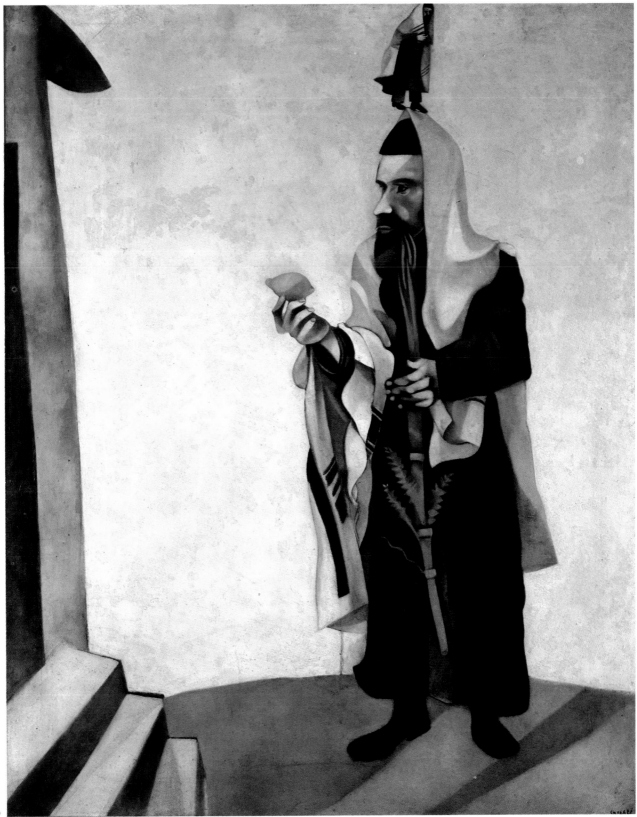

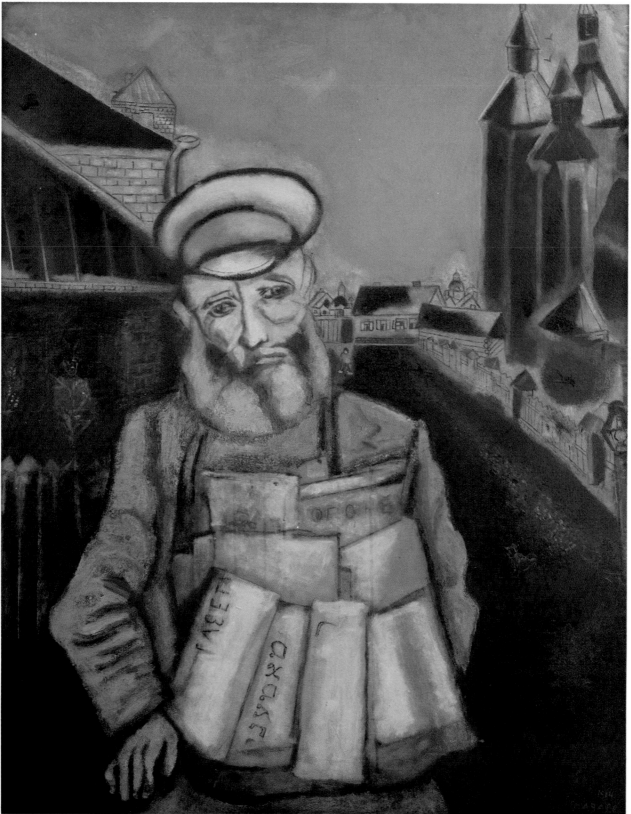

30. *The News Vendor*. 1914.
 Oil on canvas, 98 × 78.5 cm.
 Private collection, Paris.

31. *The Poet Lying Down*. 1915.
 Oil on cardboard, 77 × 77.5 cm.
 The Trustees of the Tate Gallery, London.

32. *Anywhere Out of the World*. 1915.
 Oil on cardboard, 56 × 45 cm.
 Private collection, Switzerland.

31

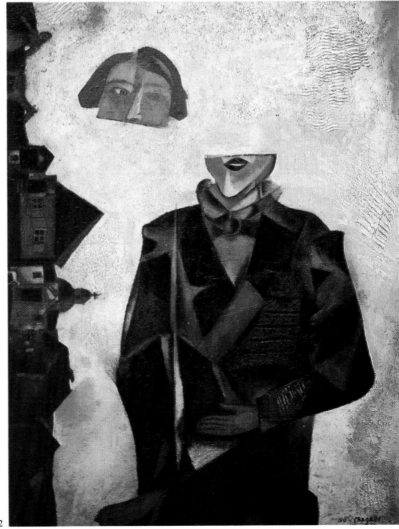

32

33. *Bella in a White Collar*. 1917.
 Oil on canvas, 149×72 cm.
 The artist's collection.

34. *The Green Fiddler*. 1918.
 Oil on canvas, 195.6×108 cm.
 The Solomon R. Guggenheim Museum, New York.
 Solomon R. Guggenheim Donation

35. *The Apparition*. 1917.
 Oil on canvas, 157×140 cm.
 Ministry of Culture, Leningrad.

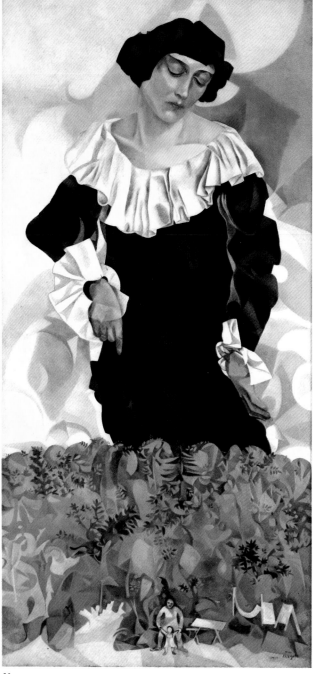

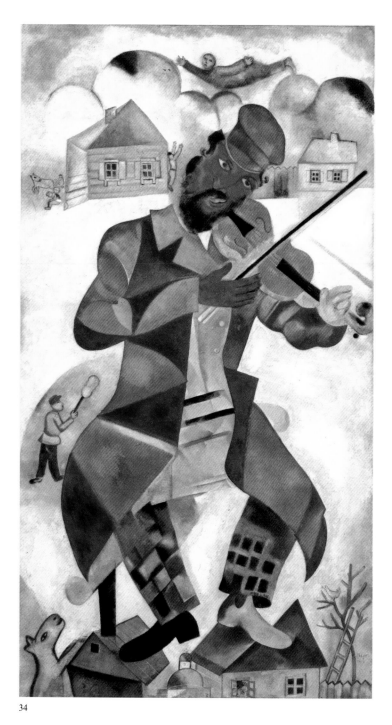

33 34

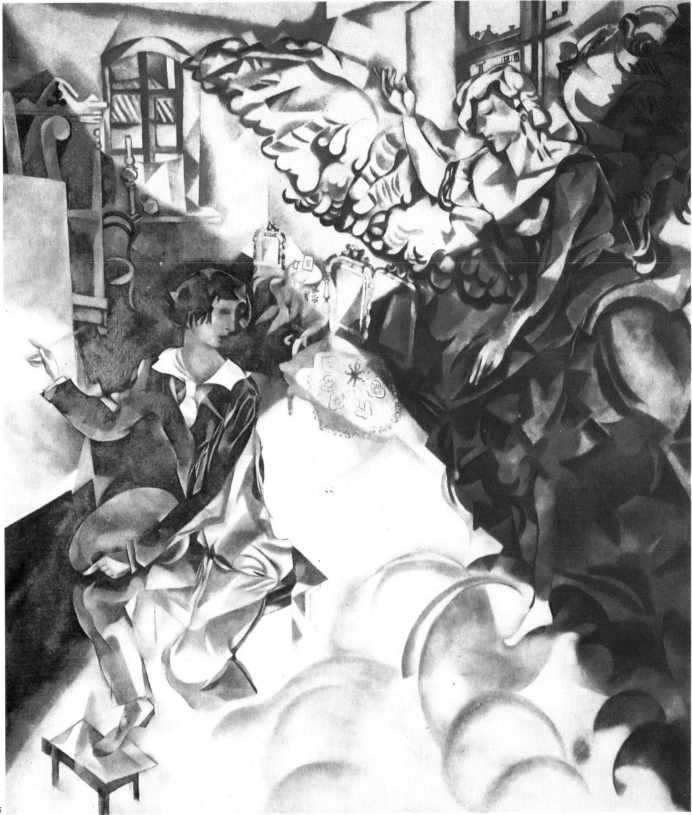

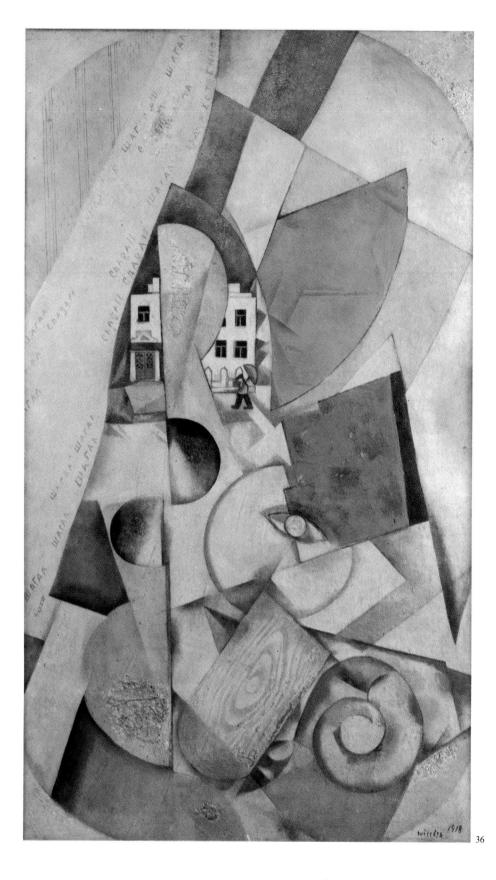

36

36. *Cubist Landscape*. 1918.
 Oil on canvas, 100×59 cm.
 Private collection, Paris.

37. *The Man with the Goat*. 1919.
 Pencil and watercolour, 360×266 cm.
 The artist's collection.

38. *Collage*. 1921.
 Pencil, pen-and-ink, papers cut out and glu
 34.2×27.9 cm.
 The artist's collection.

39. *Over the Town*. 1917-1918.
 Oil on canvas, 156×212 cm.
 Tretiakov Gallery, Moscow.

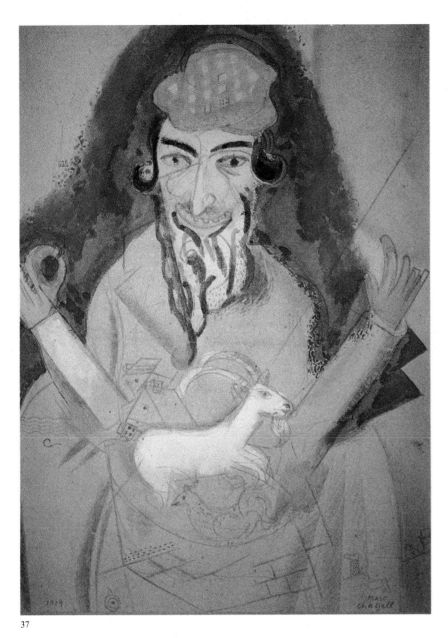

37

38

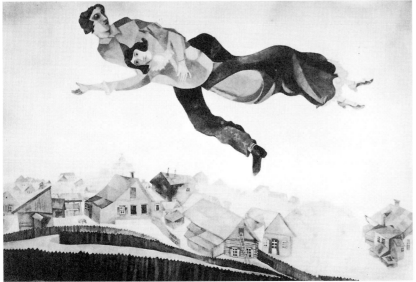

39

40. *Sketch for the Introduction to Jewish Art Theatre.* 1920.
Pencil and gouache on beige paper, 17.5 × 48 cm.
The artist's collection.

41. Model of the décor for *The Playboy of the Western World.* 1921.
Pencil, pen-and-ink and gouache on cream paper, 41 × 51 cm.
The artist's collection.

42. Costume design: *Woman Carrying a Child.* 1920.
Pencil and gouache on beige paper, 28 × 20.2 cm.
The artist's collection.

43. *Over the Town.* Circa 1924.
Oil on canvas, 67.5 × 91 cm.
Galerie Beyeler, Basel.

44. *Ida at the Window.* 1924.
Oil on canvas, 105 × 75 cm.
Stedelijk Museum, Amsterdam.

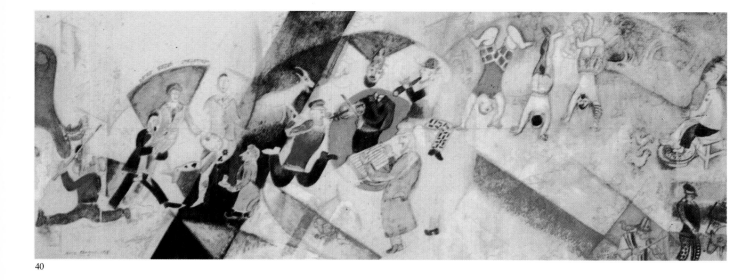

40

41

42

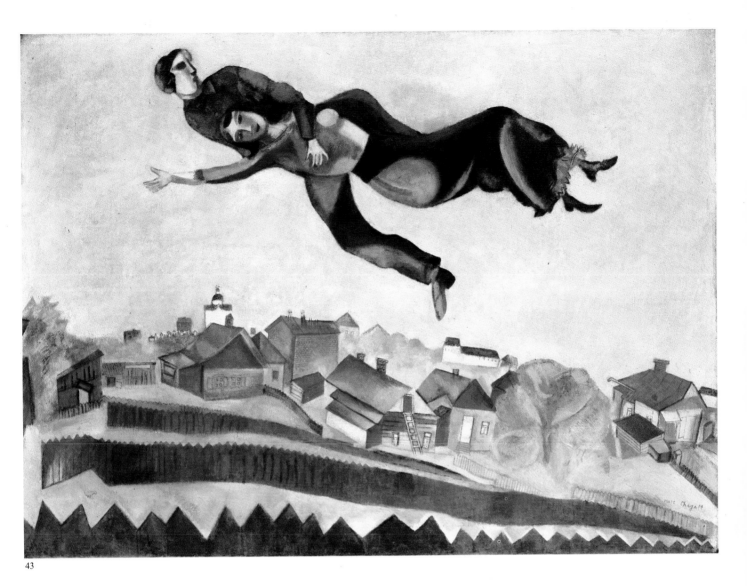

43

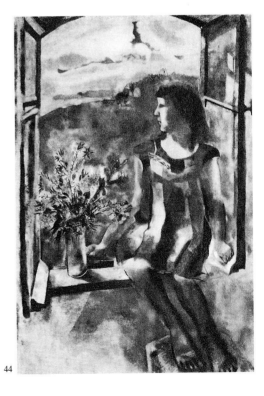

44

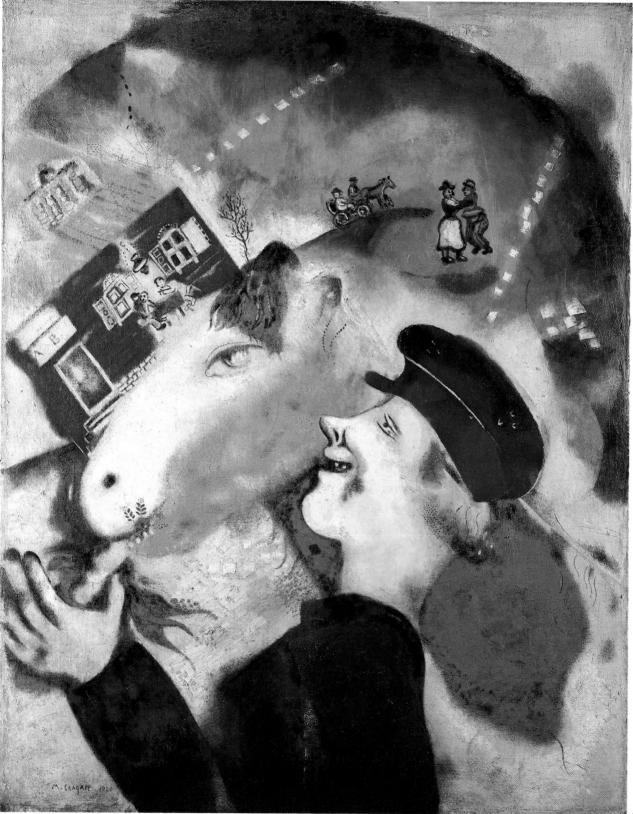

46

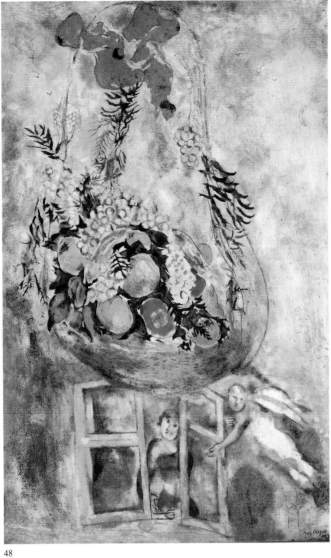

48

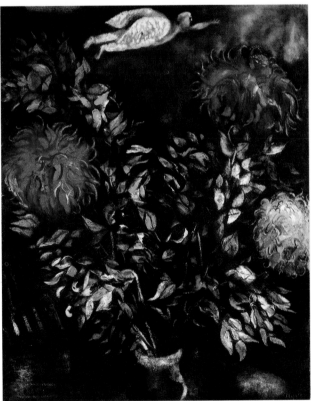

47

45. *Peasant Life*. 1925.
Oil on canvas, 100 × 81 cm.
Albright-Knox Art Gallery, Buffalo.
Room of Contemporary Art Fund.

46. *Peonies and Lilac*. 1926.
Oil on canvas, 100 × 80 cm.
Perls Galleries, New York.

47. *The Chrysanthemums*. 1926.
Oil on canvas, 92 × 72 cm.
Perls Galleries, New York.

48. *The Basket of Fruit*. 1927.
Oil on canvas, 117 × 74 cm.
Private collection.

49

50

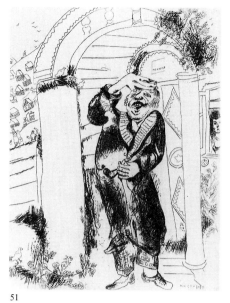

51

52

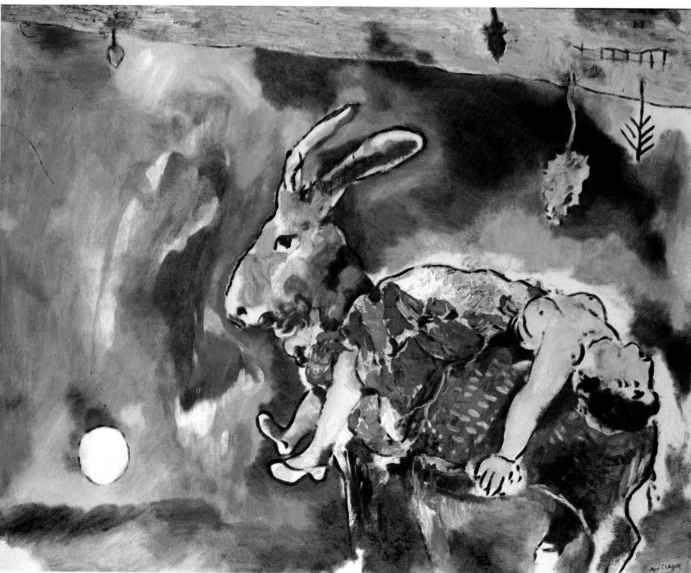

53

54

55

49. *Manilov.* 1923-1927.
(Illustration for Gogol's *Dead Souls*)
Etching and dry point, 28.5 × 22 cm.
The Art Institute of Chicago.

50. *Asking the Way.* 1923-1927.
(Illustration for Gogol's *Dead Souls*)
Etching and dry point, 28.5 × 21.5 cm.

51. *The House of the Painters.* 1923-1927.
(Illustration for Gogol's *Dead Souls*)
Etching, 29 × 23 cm.
The Art Institute of Chicago.

52. *The Dream.* 1927.
Oil on canvas, 81 × 100 cm.
Musée d'Art moderne de la Ville de Paris.

53. *The Wolf, the Goat and the Kid.* 1928-1931.
(Illustration for La Fontaine's *Fables*)
Etching, 30 × 24 cm.
Private collection.

54. *The Heron.* 1928-1931.
(Illustration for La Fontaine's *Fables*)
Etching, 29.5 × 24 cm.
Private collection.

55. *The Two Goats.* 1928-1931.
(Illustration for La Fontaine's *Fables*)
Etching, 29 × 23.5 cm.
Private collection.

56. *Still Life Beside the Window.* 1929.
Oil on canvas, 100 × 81 cm.
Göteborgs Konstmuseum, Göteborg.

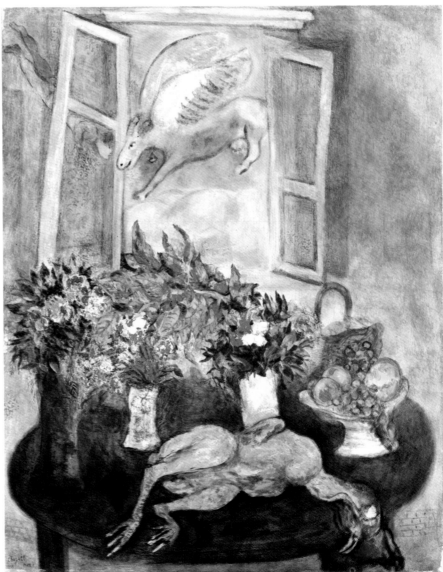

56

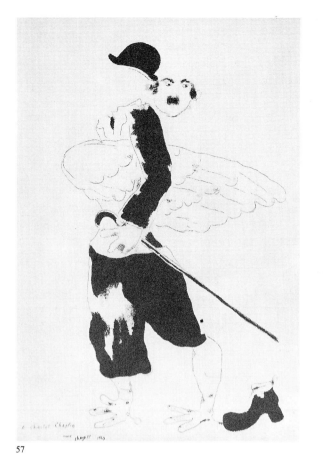

57

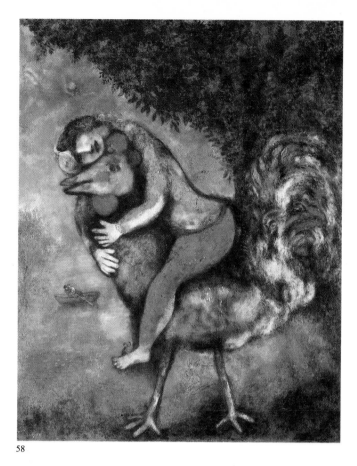

58

59

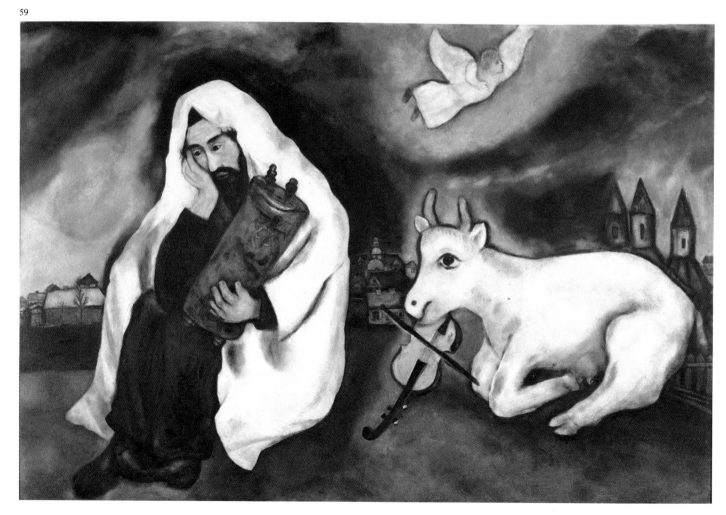

57. *To Charlie Chaplin*. 1929.
Pen drawing in India ink, 43 × 25 cm.
Private collection.

58. *The Cock*. 1929.
Oil on canvas, 81 × 65 cm.
Thyssen-Bornemisza Collection, Lugano.

59. *Solitude*. 1933.
Oil on canvas, 102 × 169 cm.
The Tel Aviv Museum.

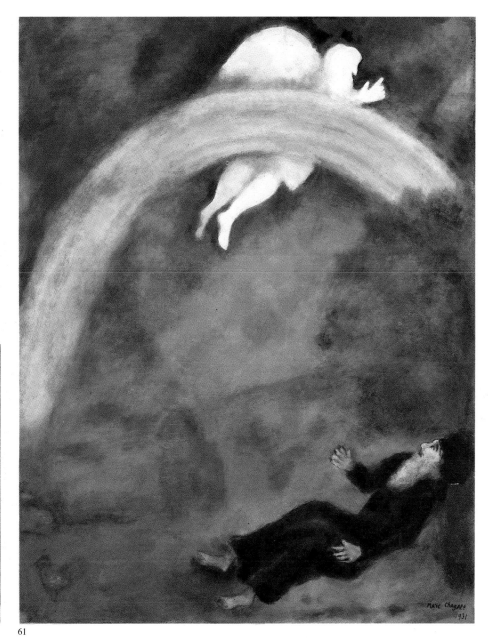

60

61

60. *Abraham Mourning Sarah*. 1931.
Gouache on paper, 62.5 × 49.5 cm.

61. *The Rainbow, Sign of the Alliance Between God and the Earth*. 1931.
Gouache on paper, 63.5 × 47.5 cm.
Musée national Message Biblique Marc Chagall, Nice.

62. *Noah Receiving the Order to Build the Ark*. 1931.
 Gouache on paper, 62 × 49 cm.
 Musée national Message Biblique Marc Chagall, Nice.

63. *Noah Releasing the Dove*. 1931.
 Oil and gouache on paper, 63.5 × 47.5 cm.
 Musée national Message Biblique Marc Chagall, Nice.

64. *Noah's Garment*. 1931.
 Gouache on paper, 63.5 × 48 cm.
 Musée national Message Biblique Marc Chagall, Nice.

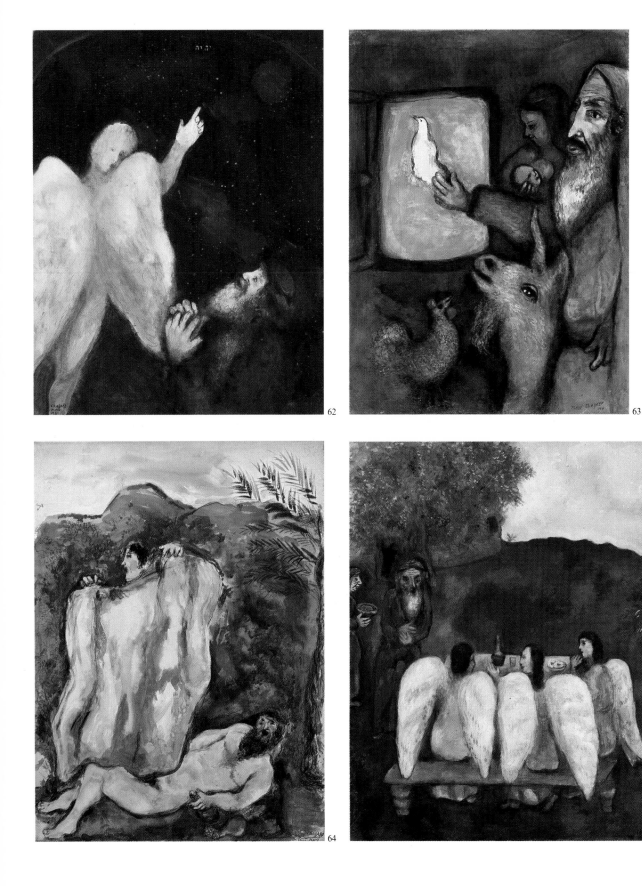

65. *The Three Angels Received by Abraham*. 1931.
 Oil and gouache on paper, 62.5 × 49 cm.
 Musée national Message Biblique Marc Chagall, Nice.

66. *Abraham Preparing to Sacrifice his Son*. 1931.
 Oil and gouache on paper, 65.5 × 52 cm.
 Musée national Message Biblique Marc Chagall, Nice.

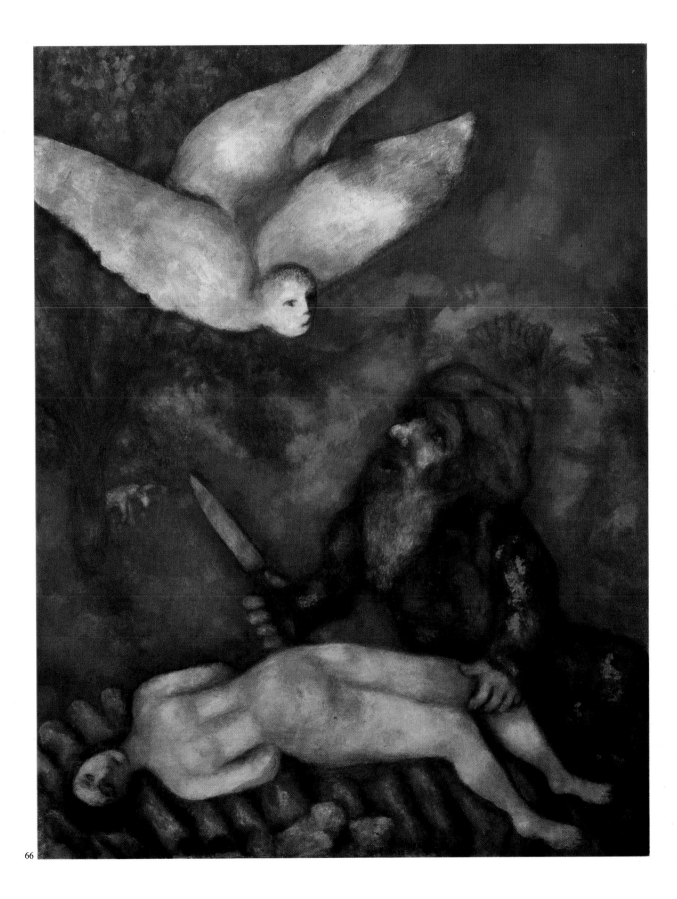

67. *The Martyr.* 1940.
 Oil on canvas, 164.5 × 139.5 cm.
 Kunsthaus, Zürich. Donated by Electrowatt SA, Zürich.

68. *The White Crucifixion.* 1938.
 Oil on canvas, 155 × 139.5 cm.
 The Art Institute of Chicago. Alfred S. Alschuler Donation.

69. *The Revolution.* 1937.
 Oil on canvas, 50 × 100 cm.
 The artist's collection.

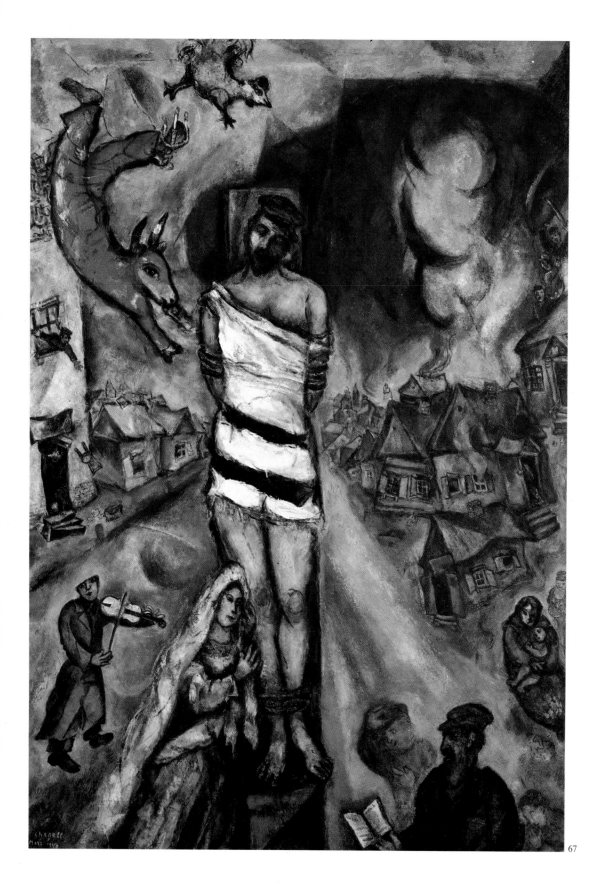

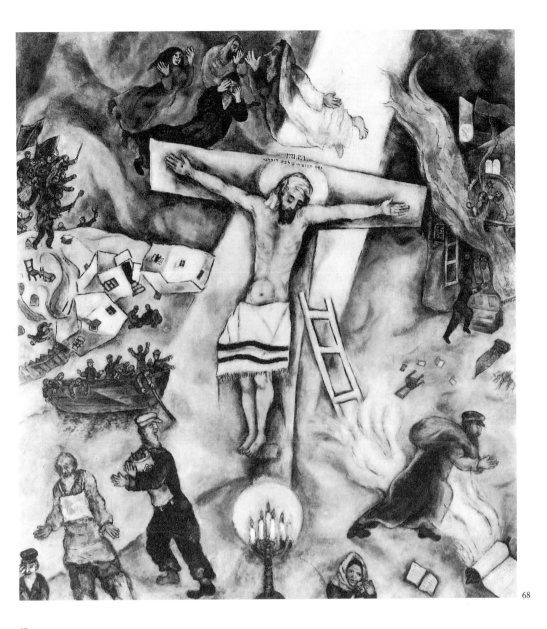

68

69

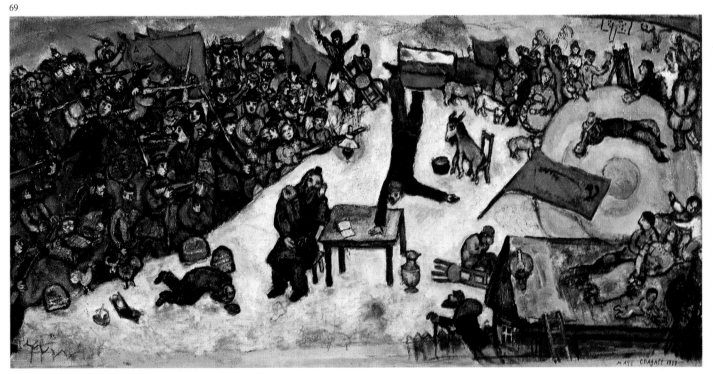

70. *The Madonna of the Village.* 1938-1942.
Oil on canvas, 102 × 98 cm.
Thyssen-Bornemisza Collection, Lugano.

71. *The Juggler.* 1943.
Oil on canvas, 109 × 79 cm.
The Art Institute of Chicago. Mrs. Gilbert Chapman Donation.

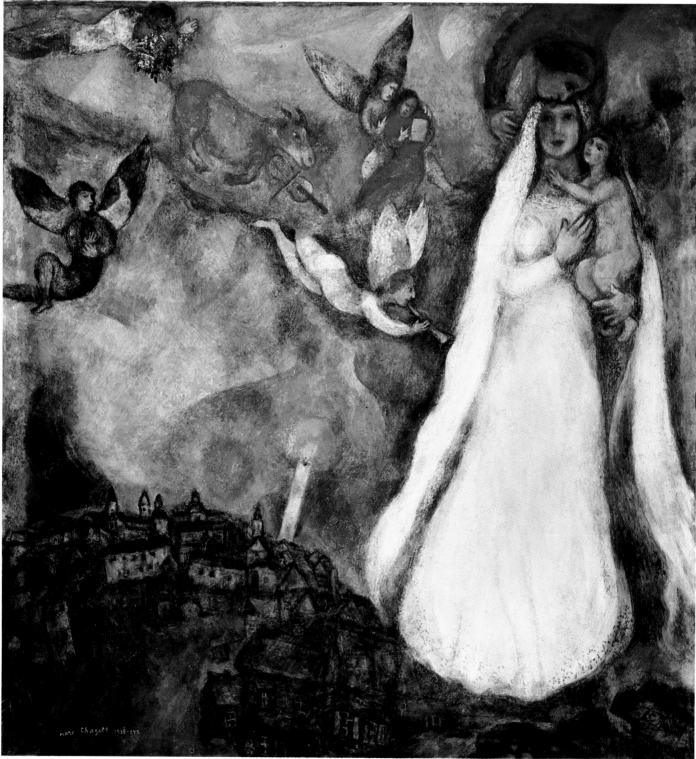

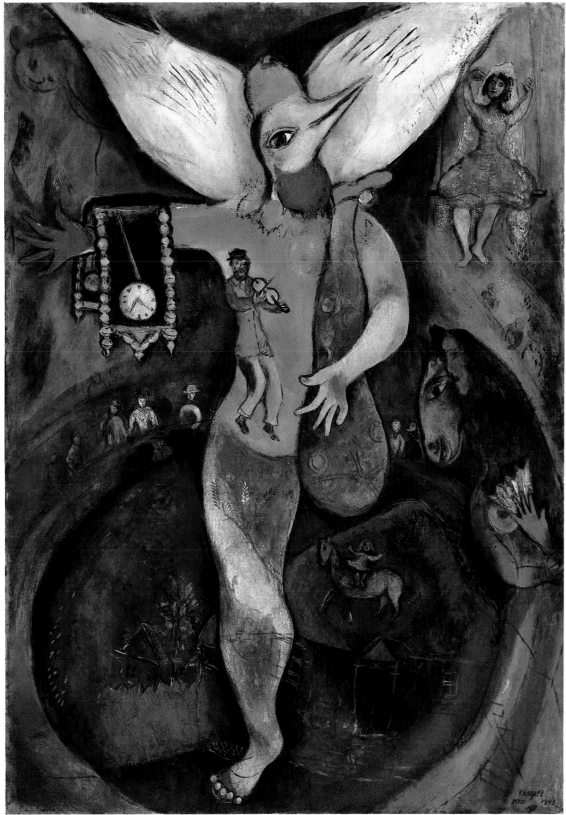

72. *The Red Horse*. 1938-1944.
Oil on canvas, 114.5 × 103 cm.
Private collection.

73. *Obsession*. 1943.
Oil on canvas, 77 × 108 cm.
Private collection.

74. *The Flying Sleigh*. 1945.
Oil on canvas, 130 × 70 cm.
The Museum of Modern Art, New York.

72

73

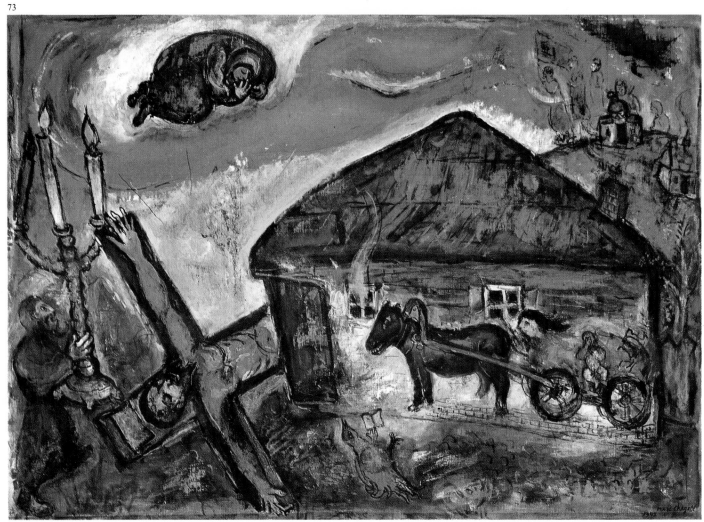

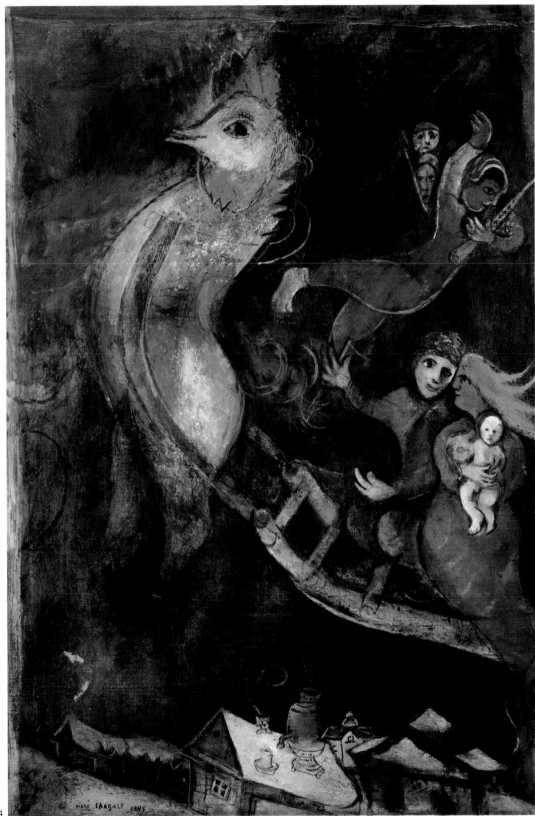

75. *Around Her.* 1945.
Oil on canvas, 131 × 110 cm.
Musée national d'Art moderne, Centre Georges Pompidou, Paris.

76. *The Lights of the Wedding.* 1945.
Oil on canvas, 123 × 120 cm.
Private collection.

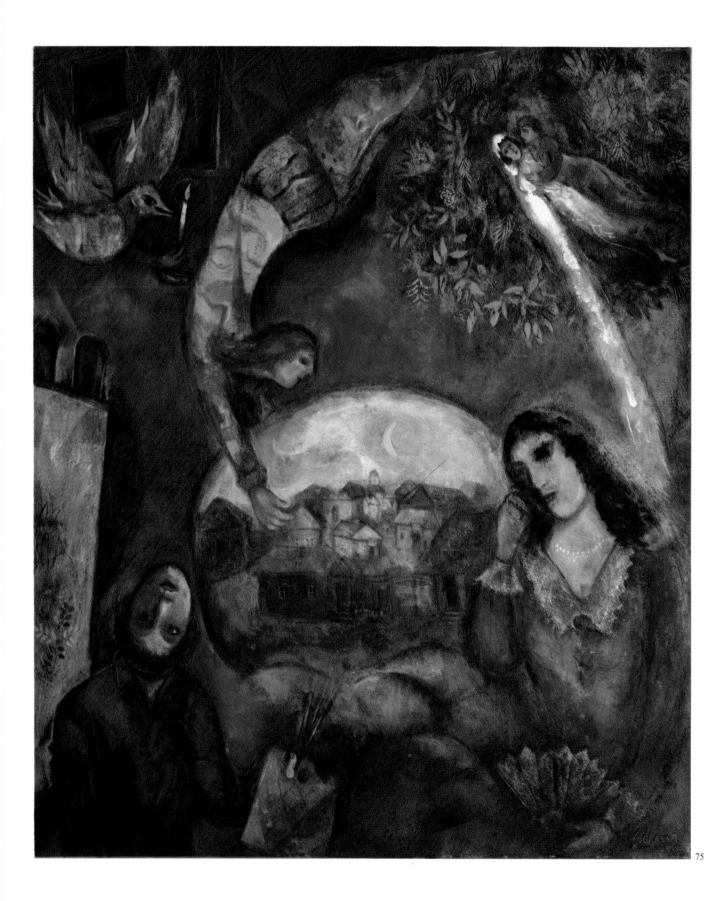

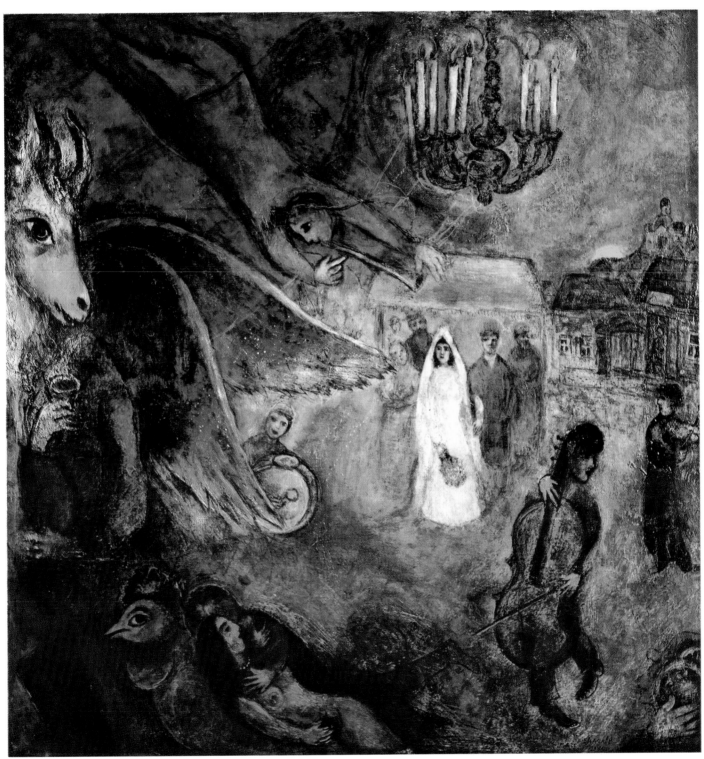

77. *The Fall of the Angel.* 1923-1947.
 Oil on canvas, 148 × 189 cm.
 Private collection, Basel.

78. *The Soul of the Town.* 1945.
 Oil on canvas, 107 × 81.5 cm.
 Musée national d'Art moderne, Centre Georges Pompidou, Paris.

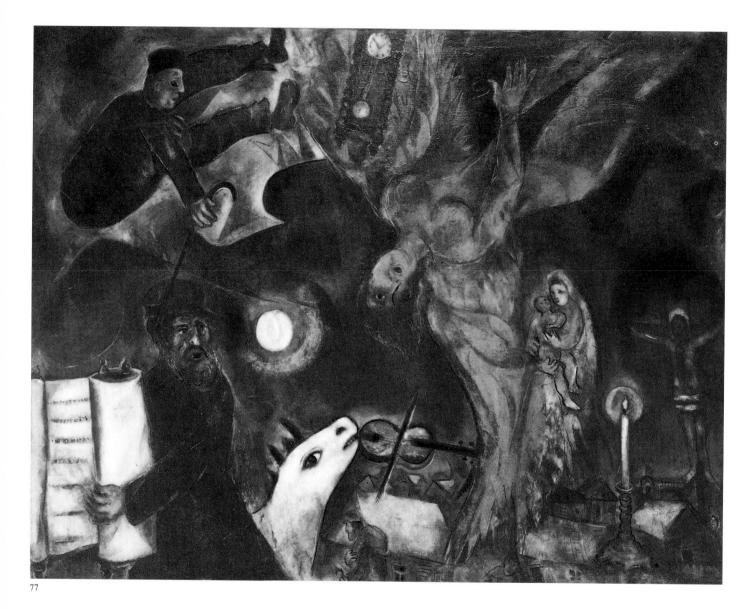

77

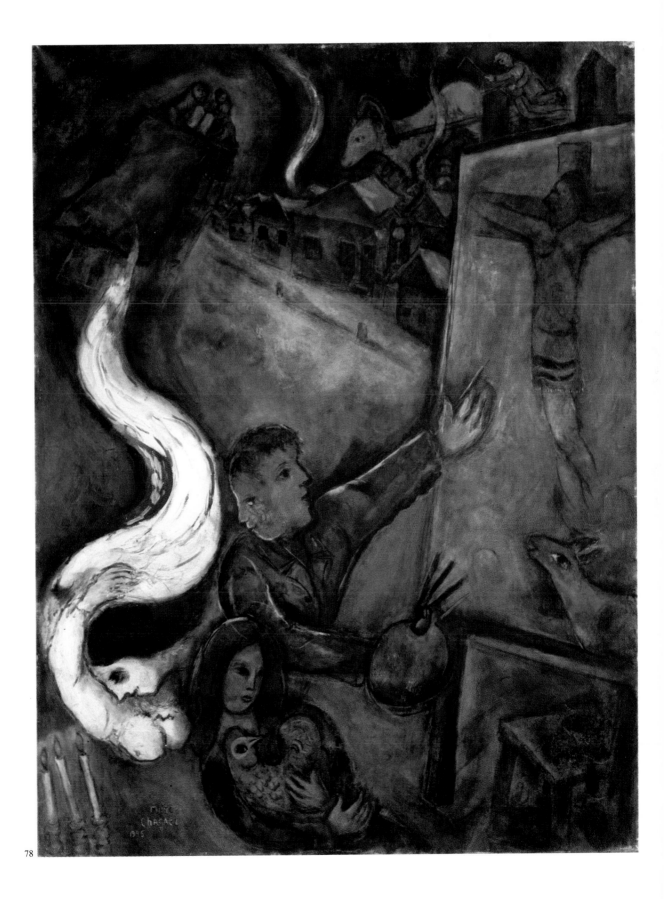

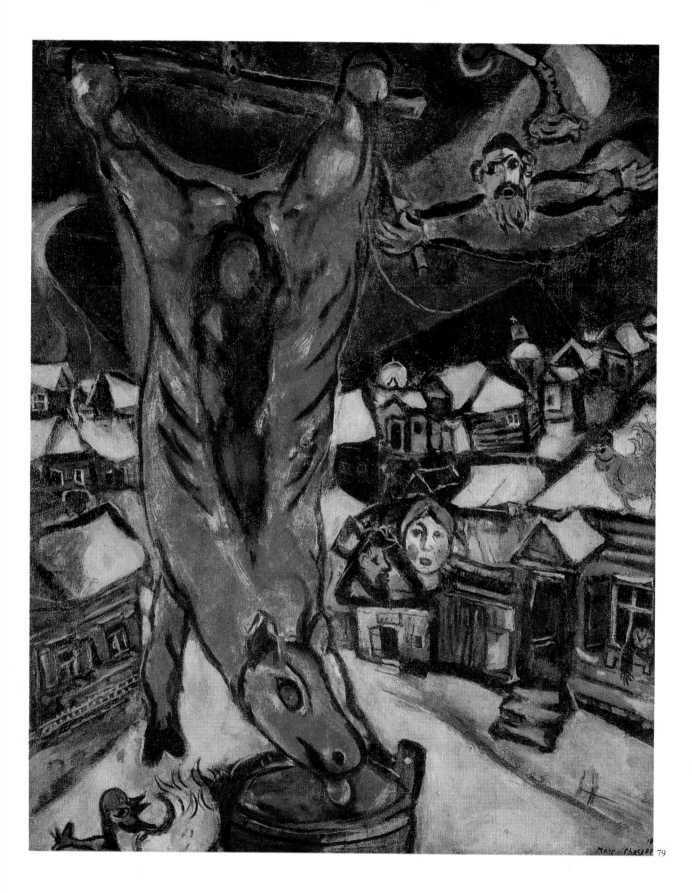

79. *The Flayed Ox.* 1947.
 Oil on canvas, 101 × 81 cm.
 Private collection, Paris.

80. *The Horse.* 1949.
 Wash drawing, 31 × 38 cm.
 Private collection.

81. *Tériade's Garden.* 1954-1955.
 Drawing in pencil, 42 × 32 cm.
 Private collection.

82. *Tériade's Window.* 1955.
 Drawing in pencil, 42 × 32 cm.
 Private collection.

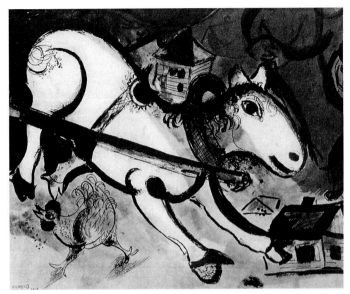

80

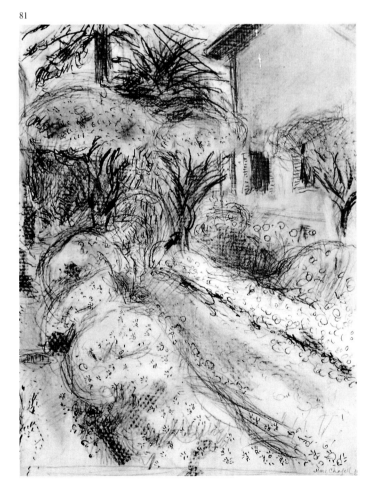

81

82

83. *Portrait of Vava.* 1953-1956.
Oil on canvas, 95 × 73 cm.
The artist's collection.

84. *To Paul Gauguin.* 1956.
Oil on canvas, 119 × 152 cm.
Private collection.

85. *The Exodus.* 1952-1966.
Oil on canvas, 130 × 162 cm.
The artist's collection.

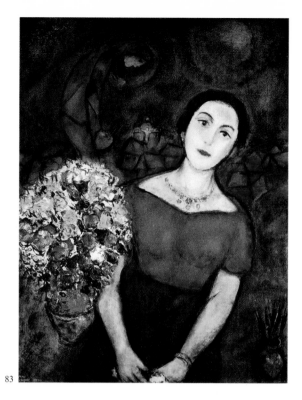

83

84

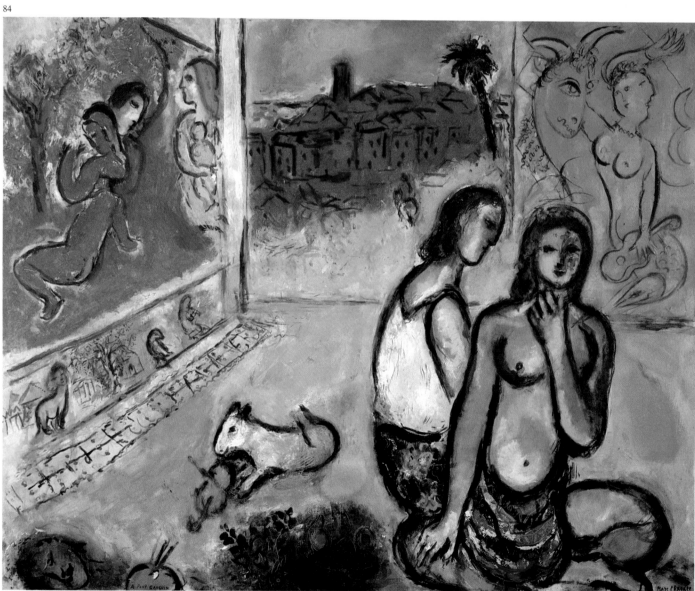

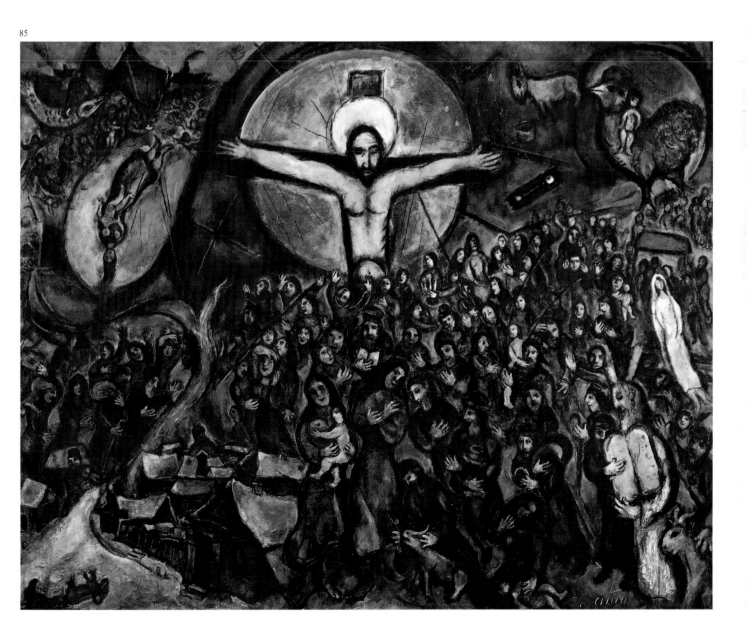

86. *Roses and Mimosa.* 1956.
Oil on canvas, 145 × 113 cm.
Evelyn Sharp Collection.

87. *The Gladioli.* 1955-1956.
Oil on canvas, 130 × 97 cm.
Gustav Zumsteg Collection, Zürich.

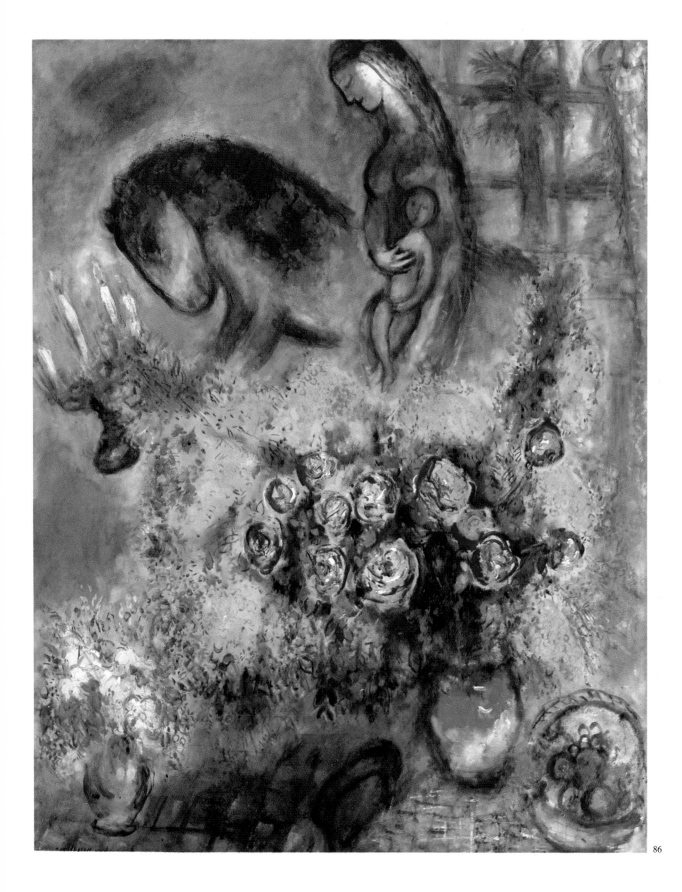

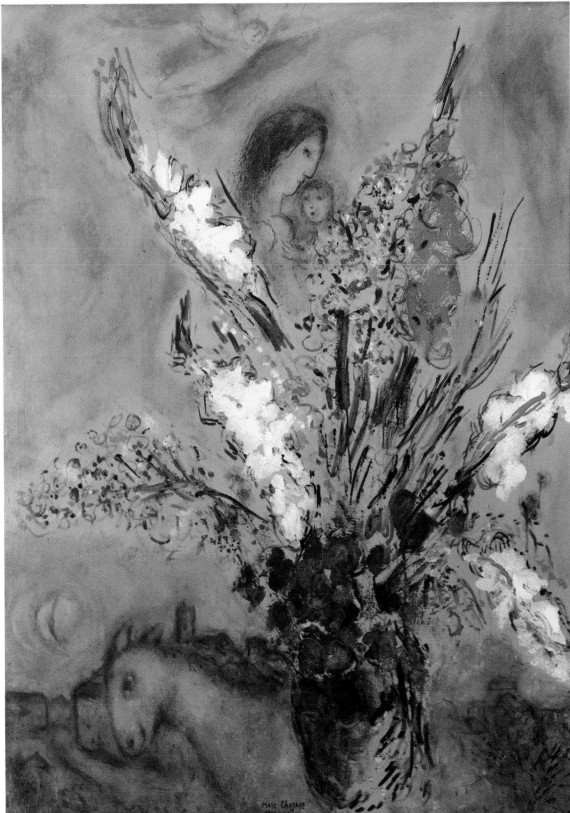

88. *The Song of Songs III*. 1960.
 Oil on canvas, 149 × 230 cm.
 Musée national Message Biblique Marc Chagall, Nice.

89. *Jacob's Dream*. 1954-1967.
 Oil on canvas, 195 × 278 cm.
 Musée national Message Biblique Marc Chagall, Nice.

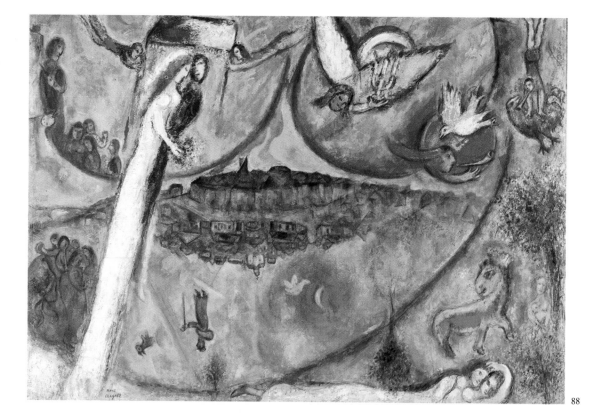

88

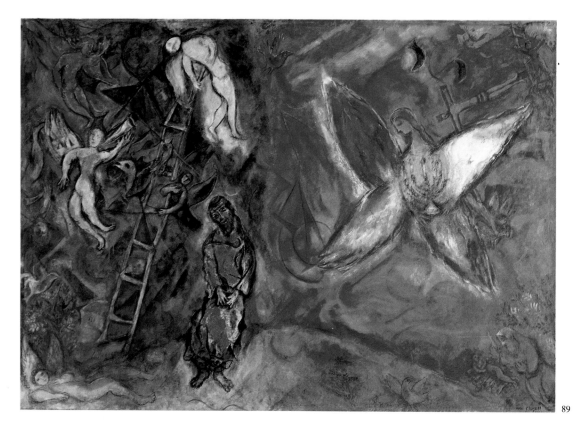

89

90. *Adam and Eve Driven out of Paradise.* 1954-1967.
Oil on canvas, 190 × 284 cm.
Musée national Message Biblique Marc Chagall, Nice.

91. *Abraham and the Three Angels.* 1954-1967.
Oil on canvas, 190 × 292 cm.
Musée national Message Biblique Marc Chagall, Nice.

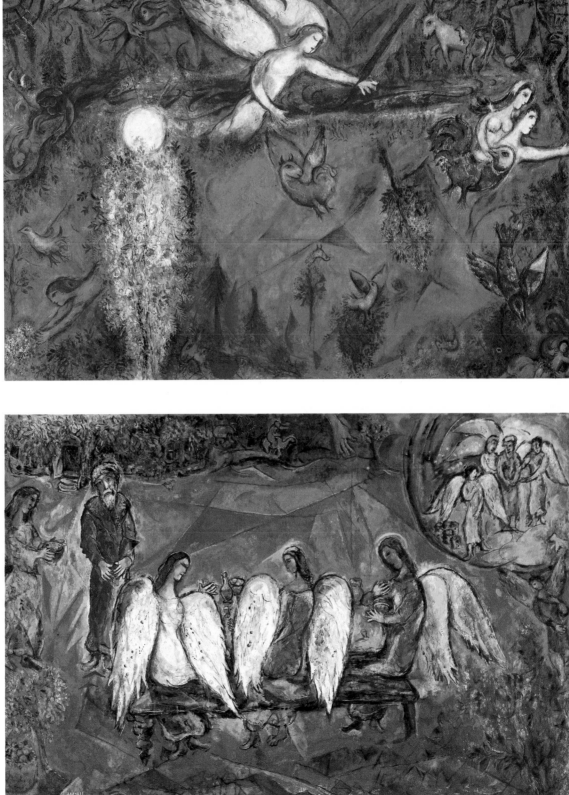

90

91

92. *The Concert*. 1957.
 Oil on canvas, 140×239.5 cm.
 Evelyn Sharp Collection.

93. *Design for Phileton's Costume in "Daphnis and Chloe"*. 1958.
 Pencil, watercolour and pastel on grey Canson paper, 38×26.5 cm.
 The artist's collection.

94. *The Mermaid of the Baie des Anges*. 1962.
 Poster, 99×62 cm.
 Édition du Commissariat du Tourisme Français.

95. *The Woman with the Blue Face*. 1932-1960.
 Oil on canvas, 100×82 cm.
 Private collection.

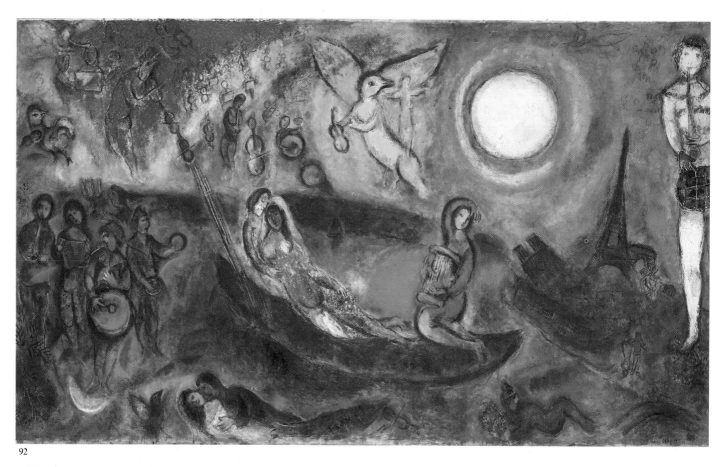

92

93

94

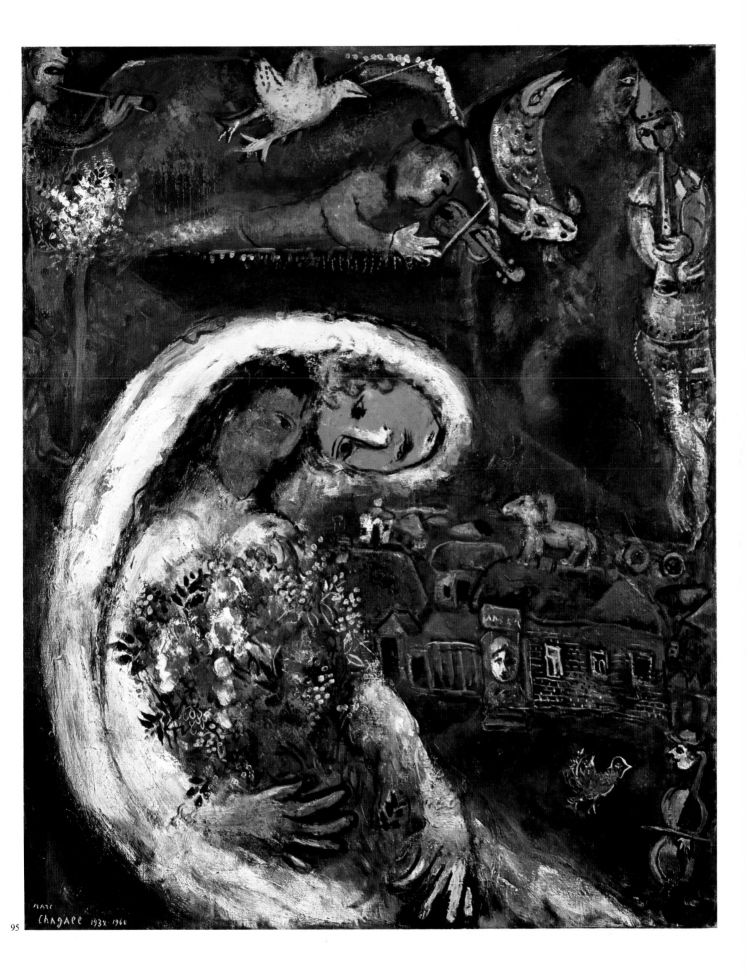

95

96. *David*. 1962-1963.
 Oil on canvas, 180 × 98 cm.
 Private collection.

97. *Bathsheba*. 1962-1963.
 Oil on canvas, 180 × 96 cm.
 Private collection.

98. *Paradise*. 1962.
 Oil on canvas, 199 × 288 cm.
 Musée national Message Biblique Marc Chagall, Nice.

99. *Life*. 1964.
 Oil on canvas, 296 × 406 cm.
 Fondation Marguerite et Aimé Maeght, Saint-Paul-de-Vence.

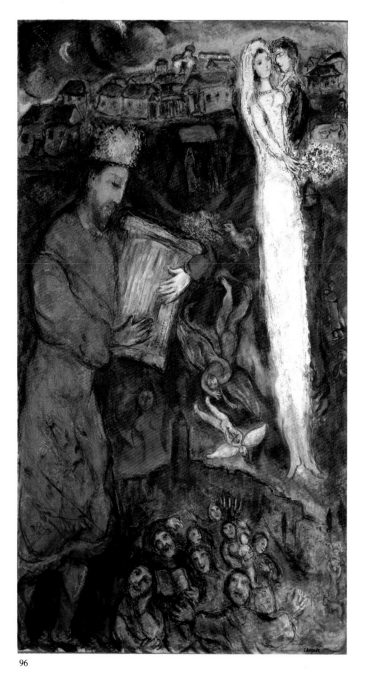

96

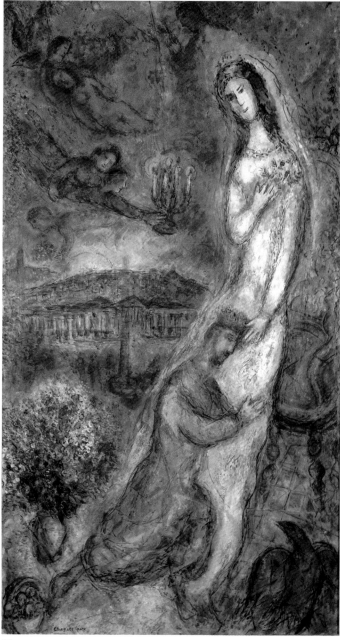

97

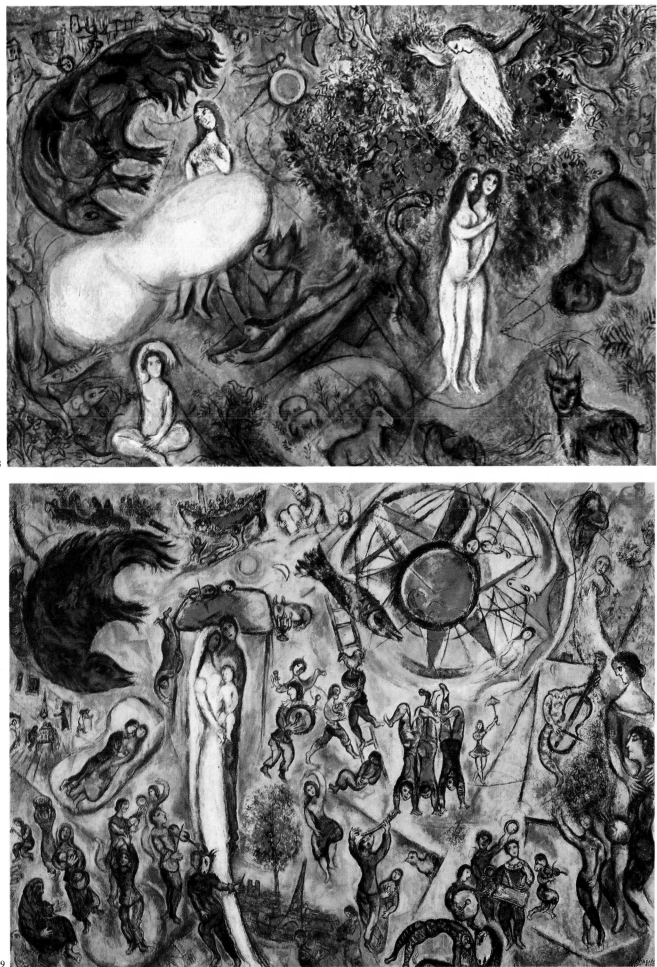

98

99

100. *Ceiling of the Paris Opera House.* 1964.
Oil on glued canvas, 220 m².

101. *The Clown with Hoops.* 1966.
Oil on canvas, 92 × 65 cm.
Private collection.

102. *The Equestrienne with the Red Horse.* 1966.
Oil on canvas, 150 × 120 cm.
The artist's collection.

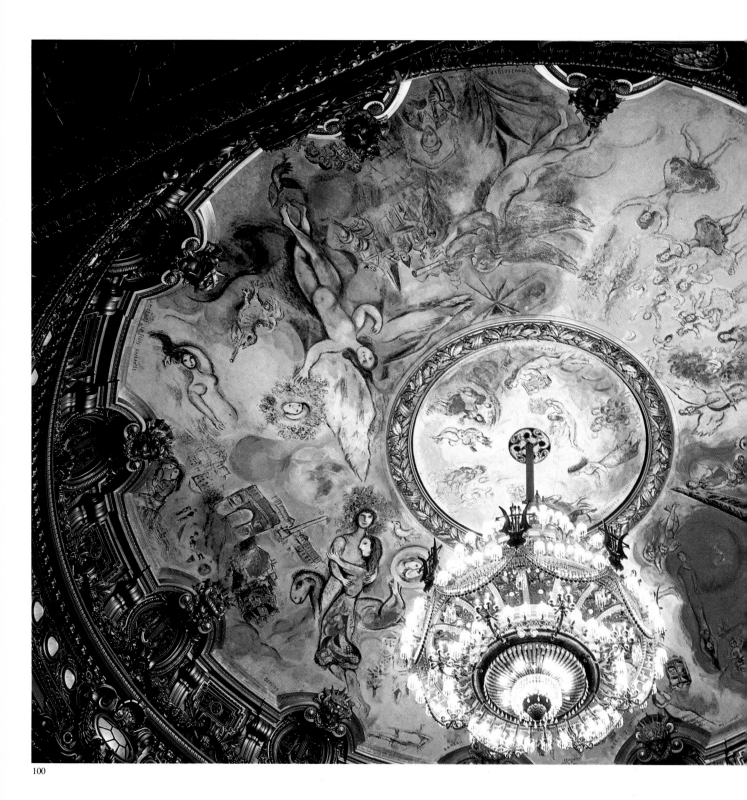

101

102

103. *The Mauve Nude.* 1965.
 Oil on canvas, 140 × 148 cm.
 Private collection.

104. *Winter.* 1966.
 Oil on canvas, 162 × 114 cm.
 The artist's collection.

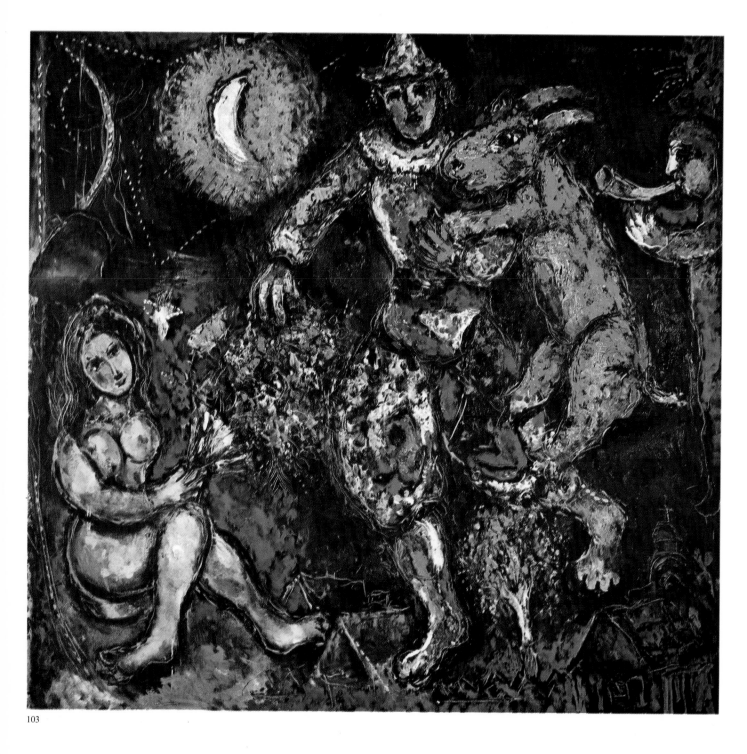

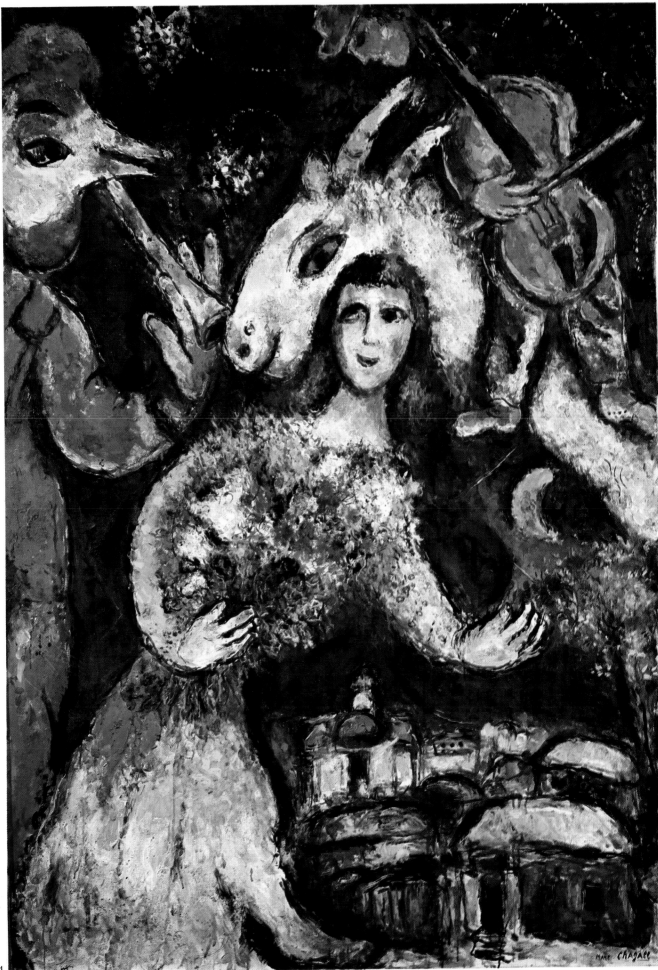

105. *War.* 1964-1966.
 Oil on canvas, 163 × 231 cm.
 Kunsthaus, Zürich. Vereinigung Zürcher Kunstfreunde.

106. *Portrait of Vava.* 1966.
 Oil on canvas, 92 × 65 cm.
 The artist's collection.

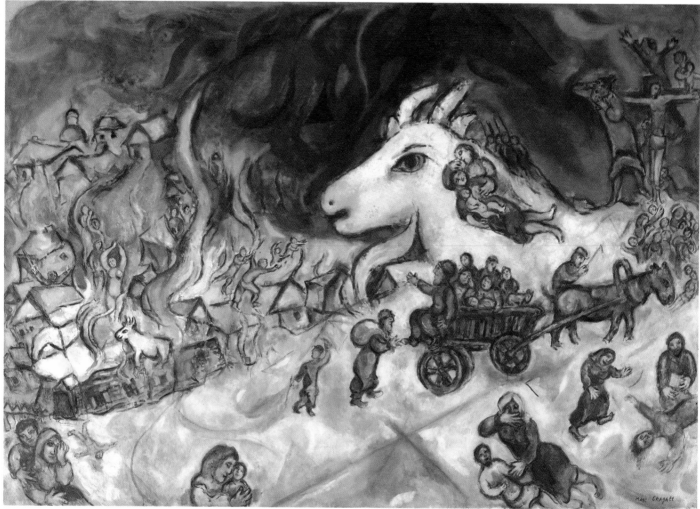

105

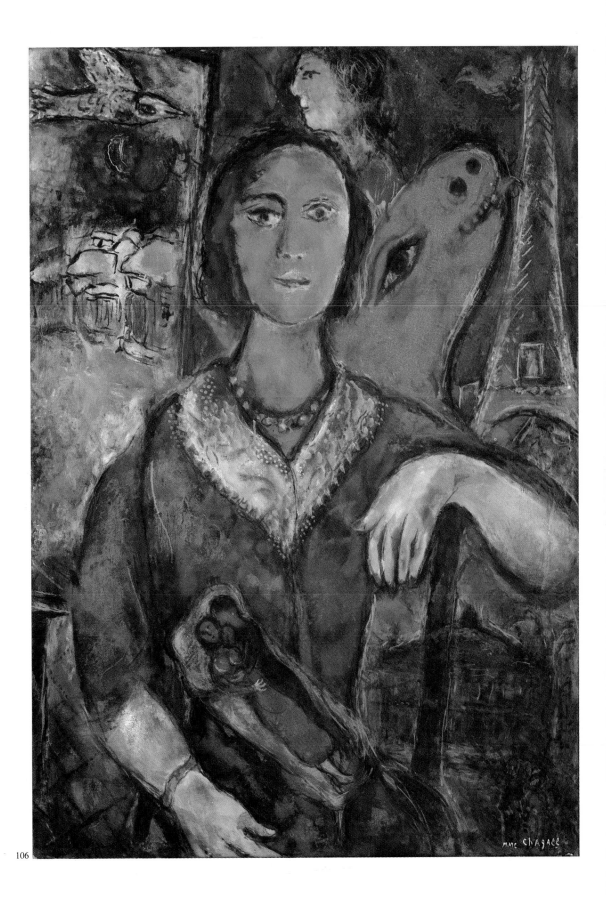

107. Model of décor for *The Magic Flute*. 1967.
 Pencil, gouache, India ink and newsprint collage, 55 × 74 cm.
 The artist's collection.

108 & 109. Costumes for *The Magic Flute*. 1967.
 Watercolours.
 Private collection.

110. *Jacob's Dream*. 1967.
 Oil on canvas, 125 × 110 cm.
 Private collection.

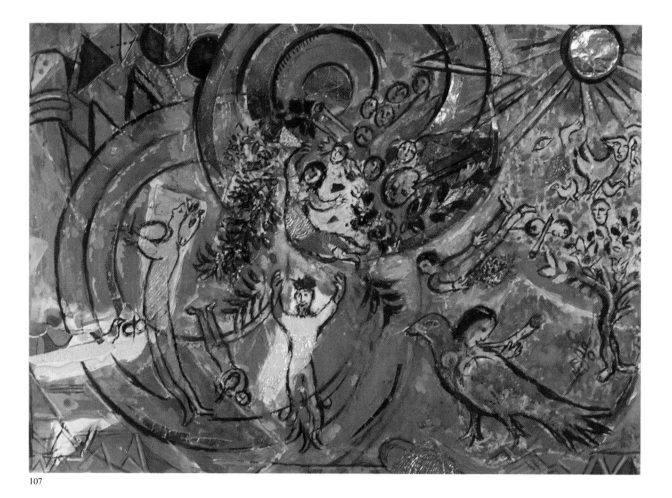

107

108

109

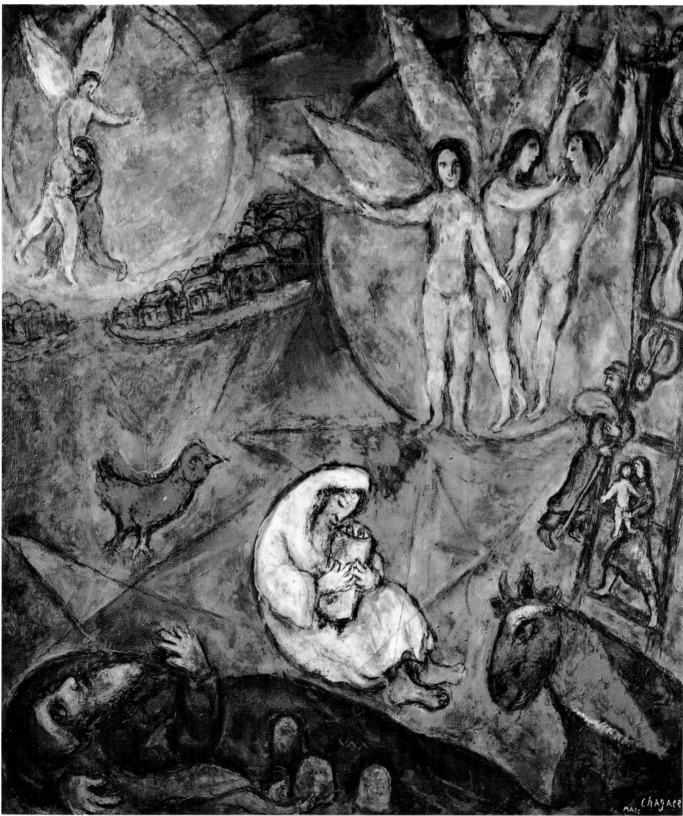

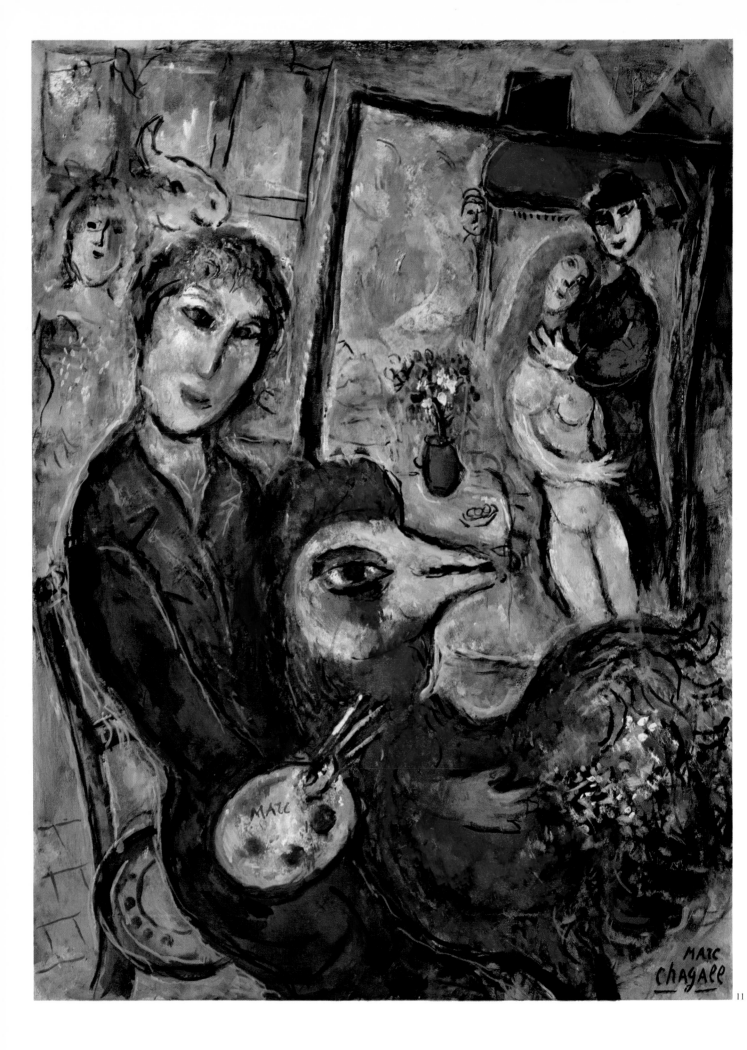

111. *The Studio.* 1959-1968.
Oil on reinforced cardboard, 65 × 49 cm.
Private collection.

112. *The Peasants of Vence.* 1967.
Oil on canvas, 112 × 82 cm.
Private collection.

113. *The Birds in the Night.* 1967.
Oil on canvas, 81 × 116 cm.
Private collection.

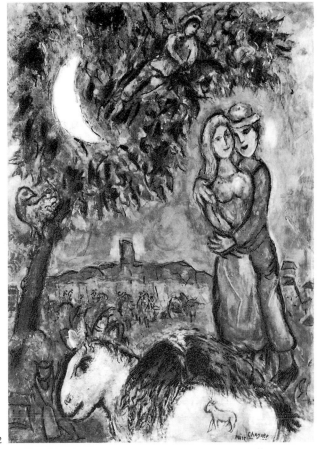

112

113

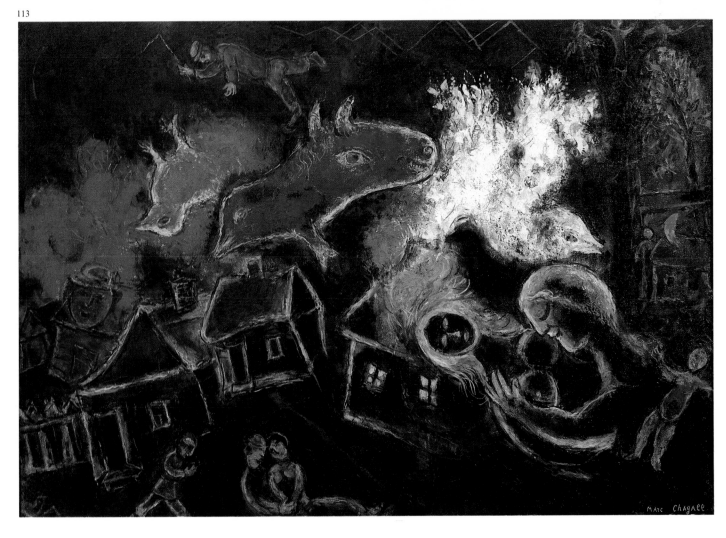

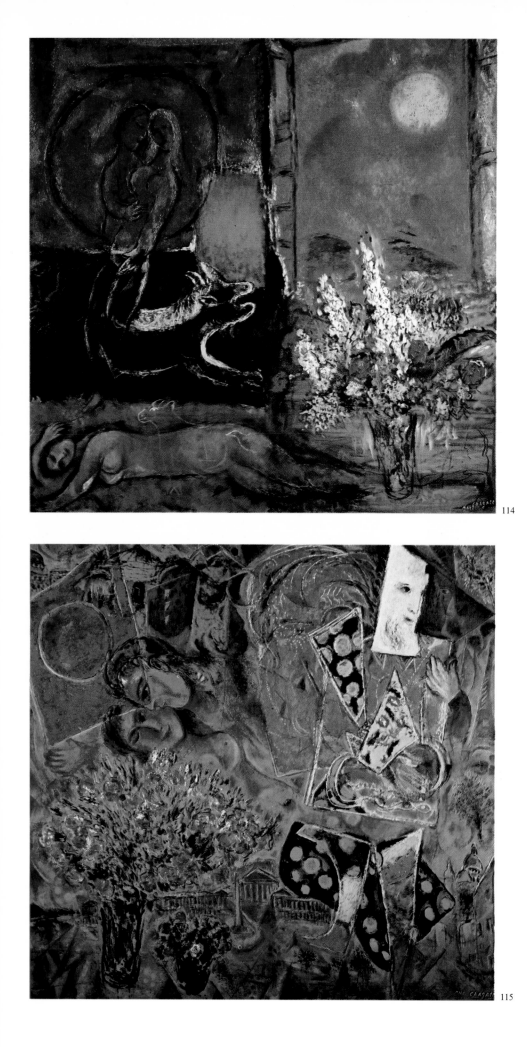

114

115

114. *The Sun of Poros.* 1968.
Oil on canvas, 160 × 160 cm.
The artist's collection.

115. *The Magician.* 1968.
Oil on canvas, 140 × 148 cm.
Private collection.

116. *The Great Circus.* 1968.
Oil on canvas, 170 × 160 cm.
Pierre Matisse Gallery, New York.

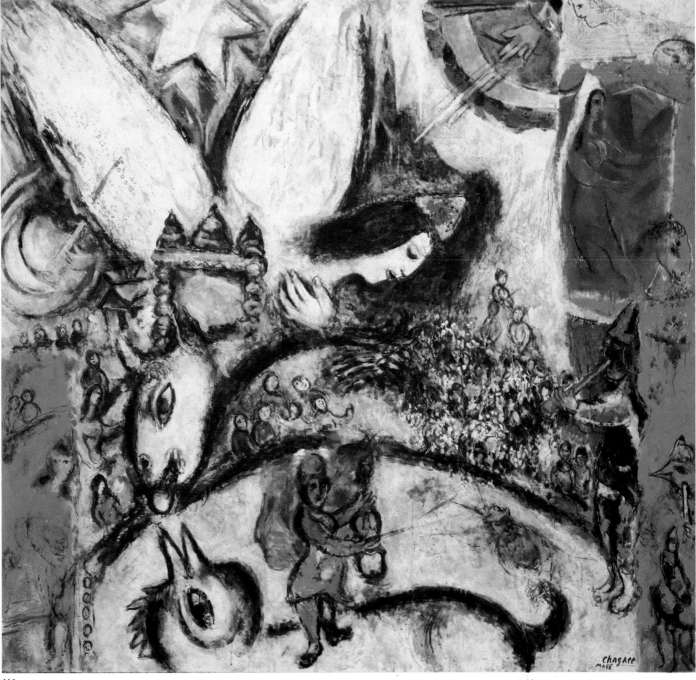

117. *Easter*. 1968.
 Oil on canvas, 160 × 160 cm.
 The artist's collection.

118. *The Painter and His Wife*. 1969.
 Oil on canvas, 92 × 73 cm.
 The artist's collection.

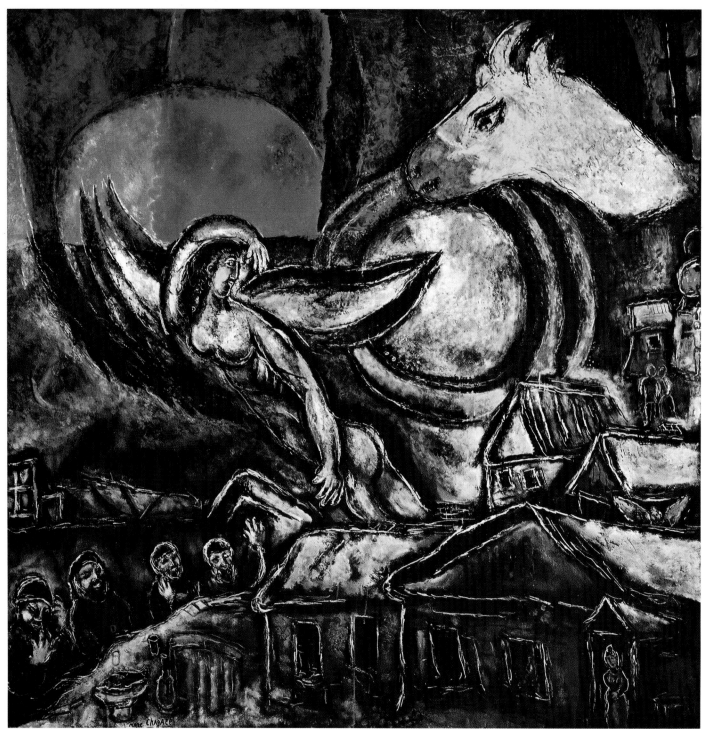

117

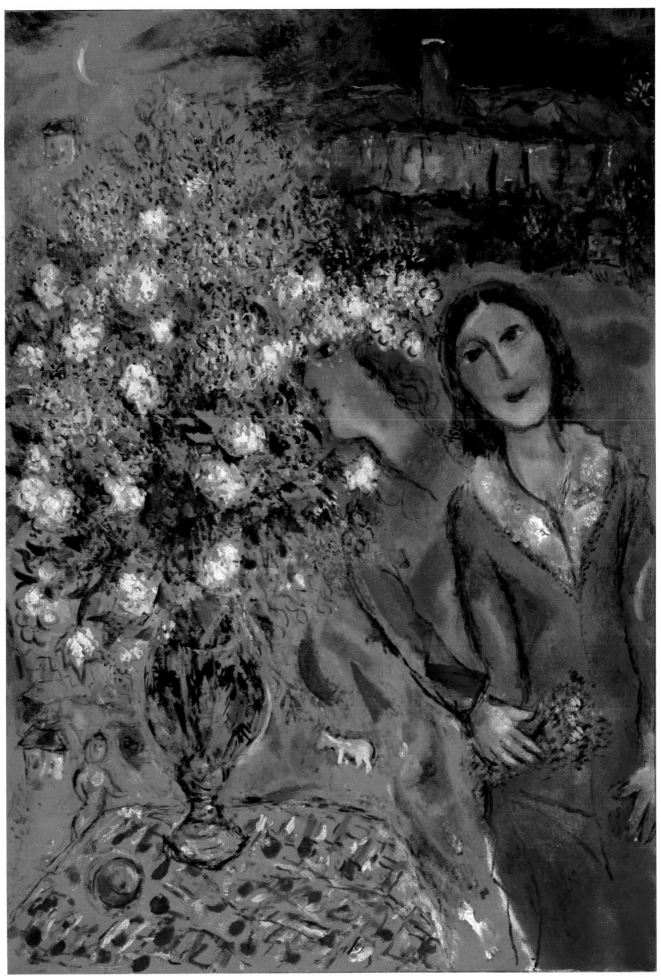

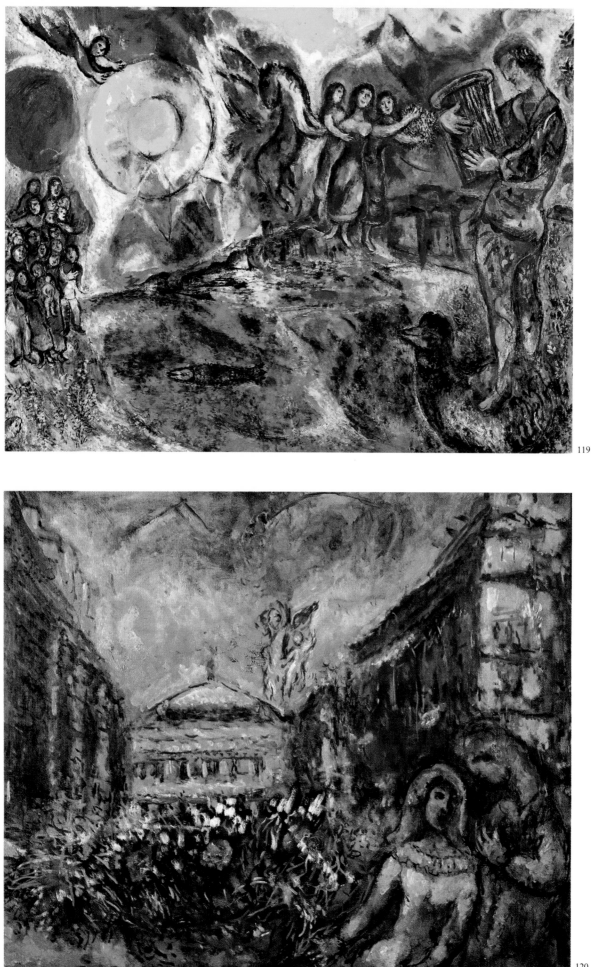

119

120

119. *Orpheus.* 1969.
Oil on canvas, 130×89 cm.
Private collection.

120. *The Avenue de l'Opéra.* 1969.
Oil on canvas, 81×65 cm.
Private collection.

121. *The Sun Bird.* 1969.
Oil on canvas, 116×89 cm.
Private collection.

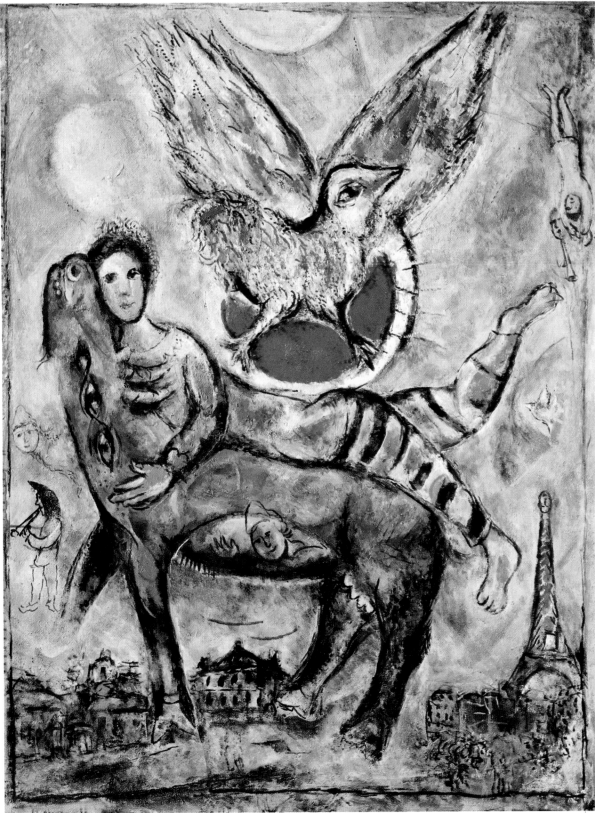

121

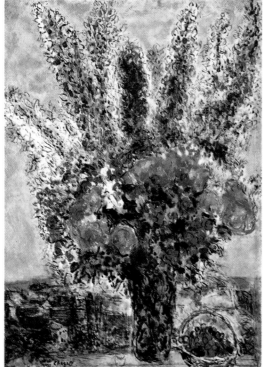

122

122. *The Bunch of Buttercups*. 1968-1971.
Oil on canvas, 100×73 cm.
Wally Findlay Galleries, New York.

123. *The Clown Lying Down*. 1968-1971.
Oil on canvas, 73×92 cm.
Private collection, Milan.

124. *Entering the Ring*. 1968-1971.
Oil on canvas, 92×73 cm.
Private collection, Milan.

123

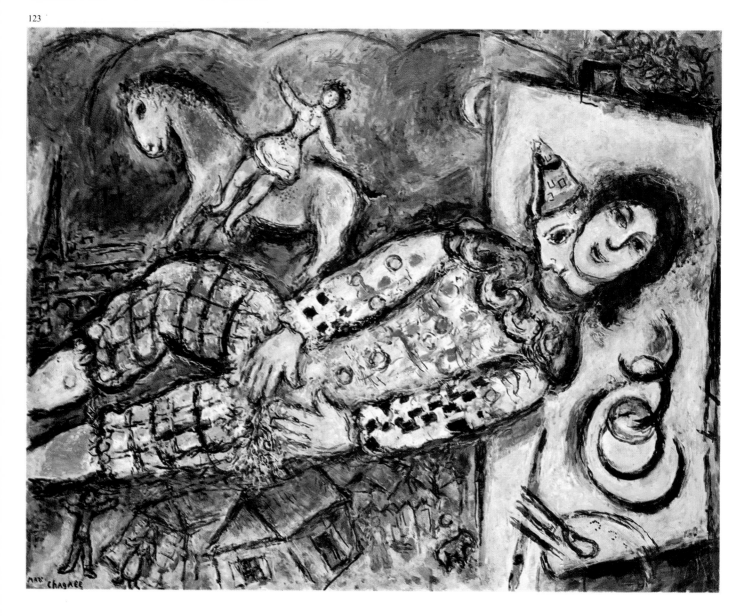

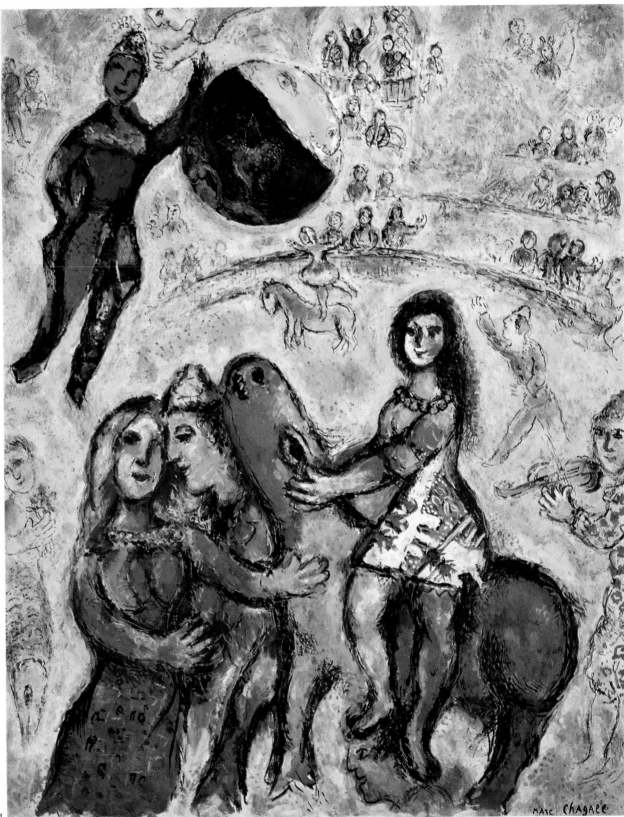

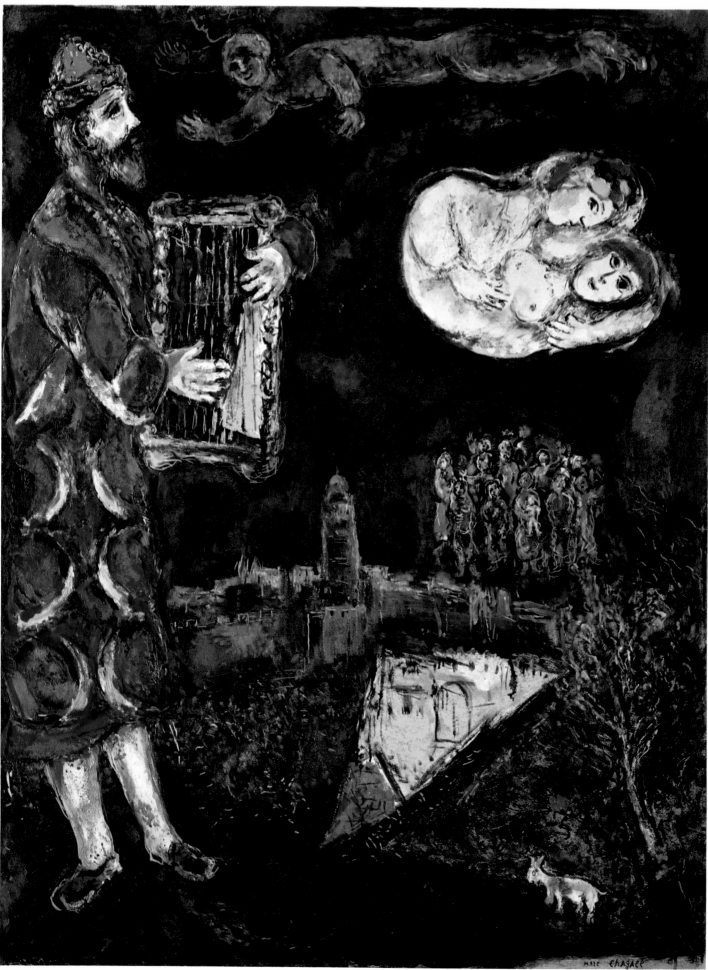

125

126

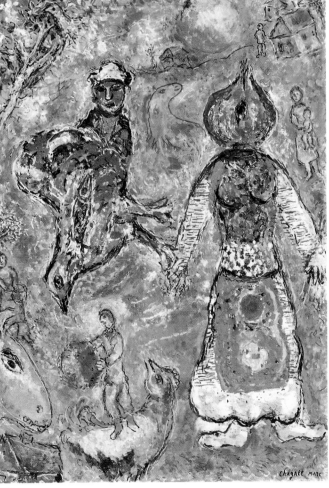

127

125. *David's Tower.* 1968-1971.
 Oil on canvas, 116 × 89 cm.
 The artist's collection.

126. *The Memento.* 1968-1971.
 Oil on canvas, 100 × 73 cm.
 Private collection, Milan.

127. *The Fantastic Village.* 1968-1971.
 Oil on canvas, 92 × 65 cm.
 The artist's collection.

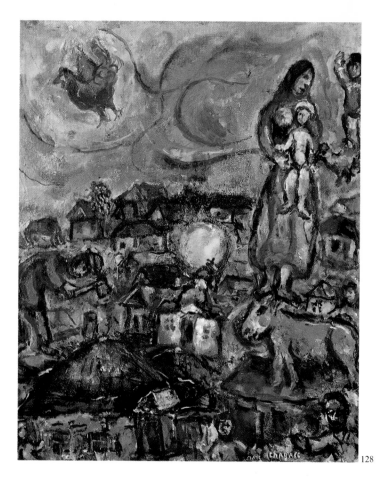

128

128. *The Woodcutter.* 1972.
Oil on canvas, 46×38 cm.
Tamenaga Gallery, Tokyo.

129. *The Accordionist.* 1973.
Gouache, 79.5×58 cm.
Private collection, Lausanne.

130. *The Circus.* 1973.
Oil on canvas, 55×46 cm.
Private collection.

131. *Crucifixion.* 1972.
Black ink, pastel and coloured pencils on pearly
Japan paper, 76.7×57.4 cm.
The artist's collection.

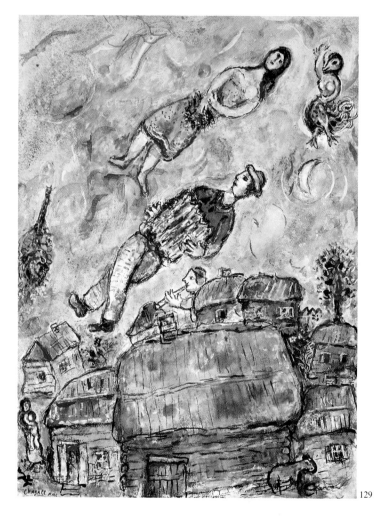

129

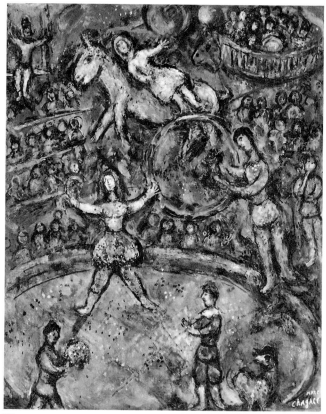

130

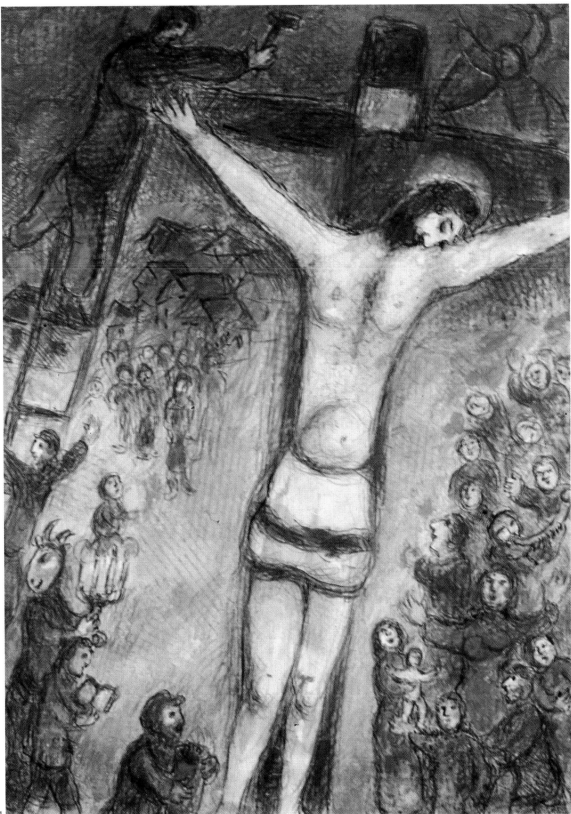

132. *The Stroll.* 1973.
 Oil on canvas, 115.5 × 81 cm.
 Pierre Matisse Gallery, New York.

133. *Don Quixote.* 1975.
 Oil on canvas, 196 × 130 cm.
 The artist's collection.

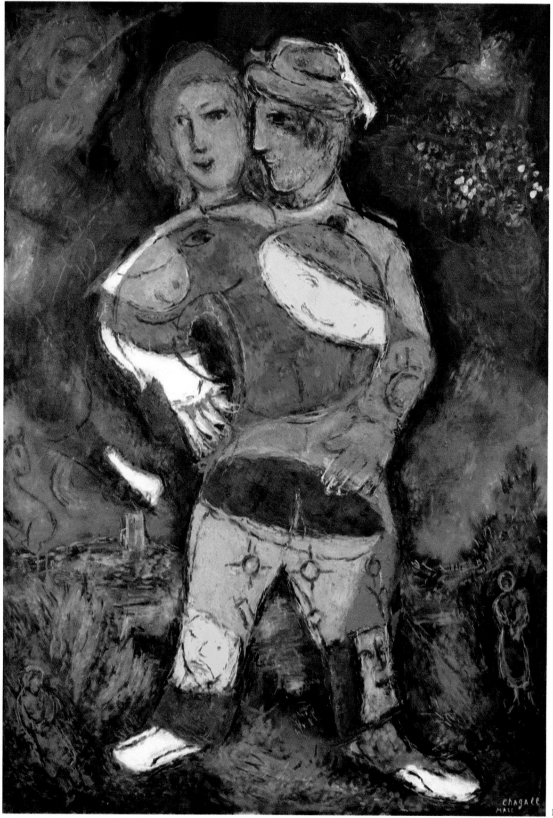

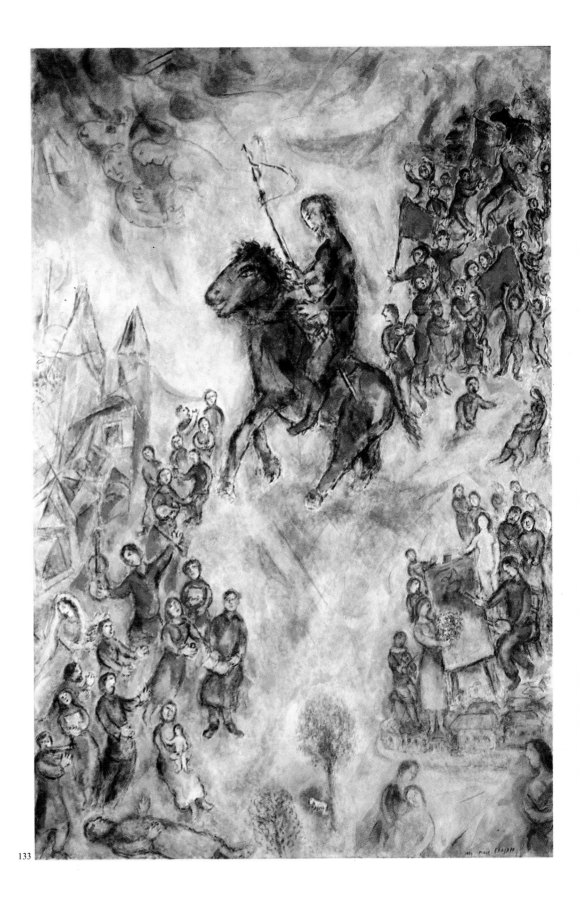

133

134

135

134. *The Myth of Orpheus.* 1977.
 Oil on canvas, 97 × 146 cm.
 The artist's collection.

135. *Paris Landscape.* 1978.
 Oil on canvas, 130 × 162 cm.
 Private collection.

136. *The Fall of Icarus.* 1975.
 Oil on canvas, 213 × 198 cm.
 Musée national d'Art moderne, Centre Georges Pompidou, Paris.

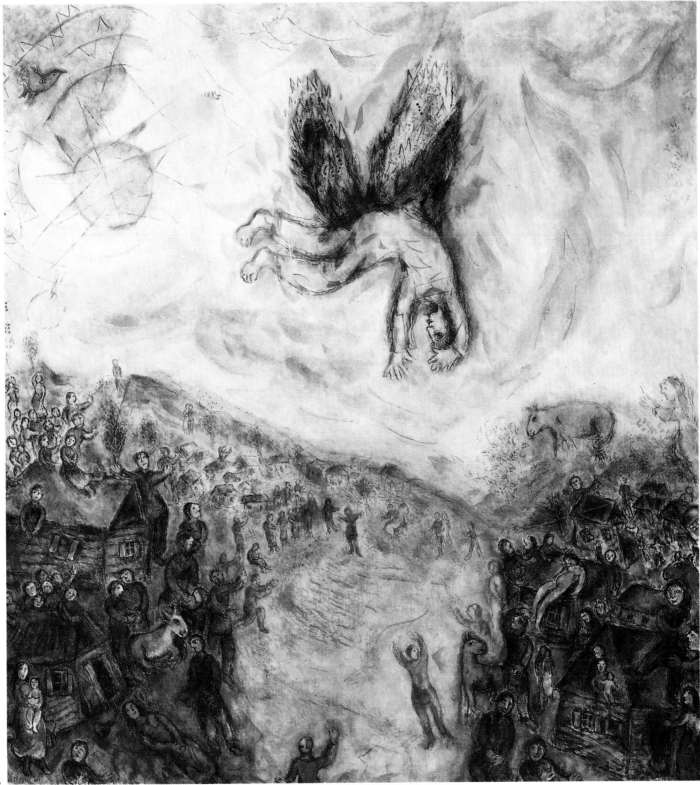

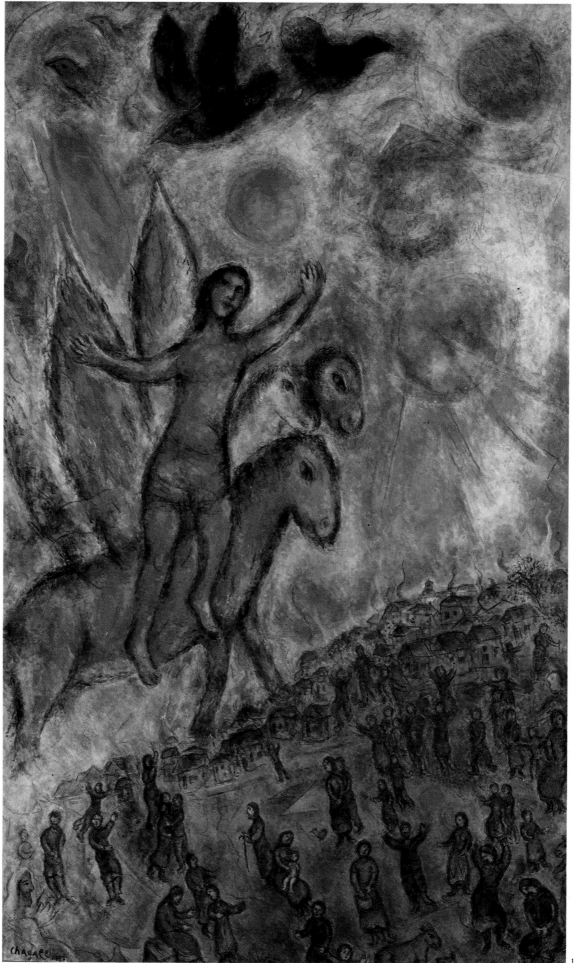

137

137. *The Chariot of the Sun.* 1977.
Oil on canvas, 195 × 120 cm.

138. *The Event.* 1978.
Oil on canvas, 130 × 162 cm.
Private collection.

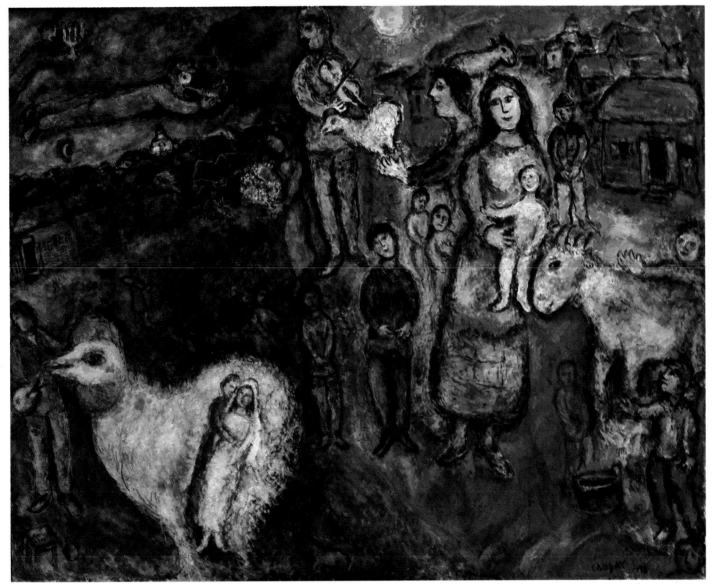

138

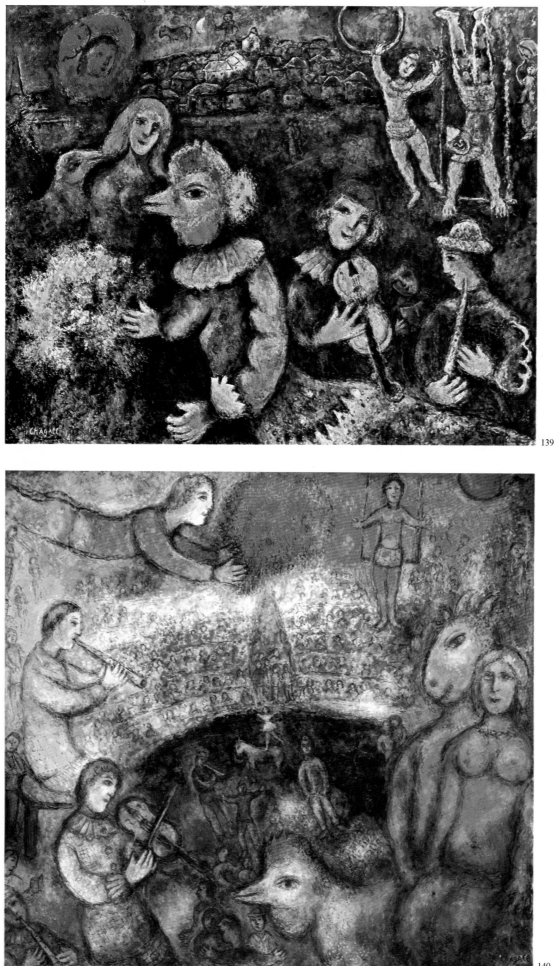

139

140

139. *Nocturnal Carnival.* 1979.
Oil on canvas, 130×162 cm.

140. *The Great Parade.* 1979-1980.
Oil on canvas, 119×132 cm.
Pierre Matisse Gallery, New York.

141. *Couple on a Red Background.* 1983.
Oil on canvas, 81×65.5 cm.
The artist's collection.

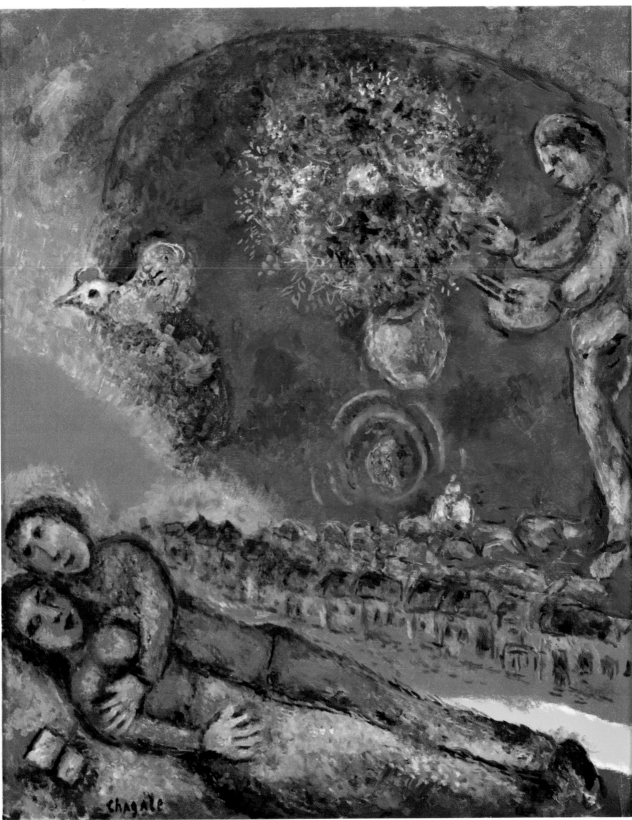

141

142. *The Lovers and the Beast.* 1957.
 Ceramic, 30 × 22 cm.

143. *The Boat.* 1957.
 Ceramic, 33 × 22 cm.

144. *The Profile.* 1957.
 Ceramic, 36 × 28 cm.

145. *Christ and the Woman of Samaria.*
 Height 52 cm.
 Ida Chagall Collection.

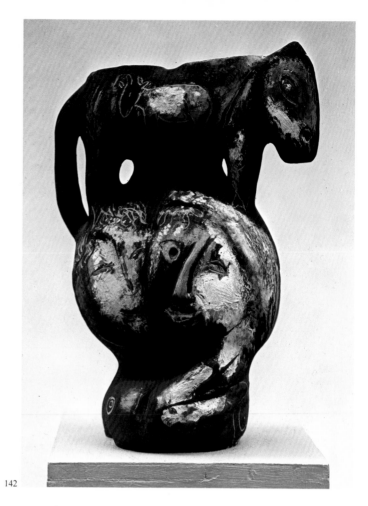

142

143

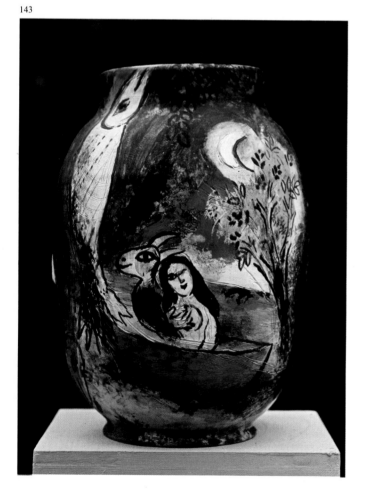

144

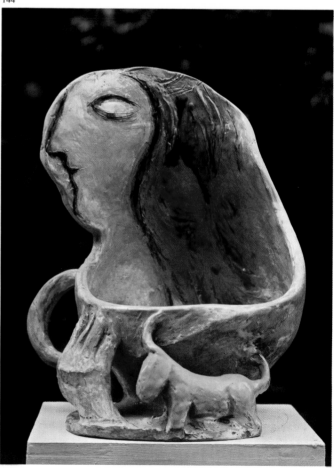

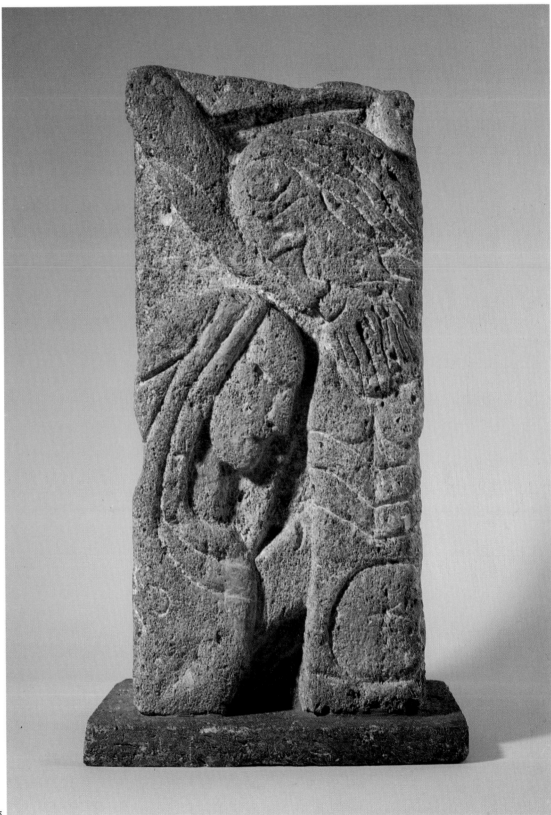

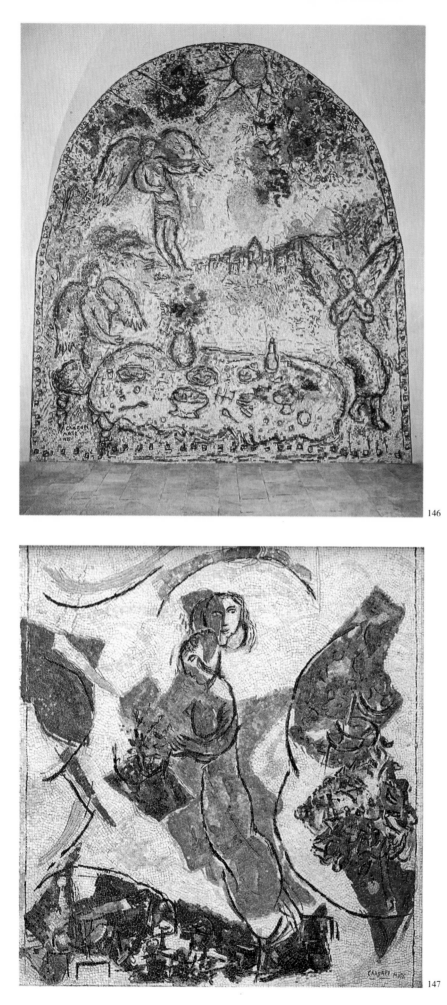

146. *The Offering.* 1975.
Mosaic, 665 × 570 cm.
Chapel of Sainte-Rosaline, Les Arcs.

147. *The Lovers.* 1964-1965.
Mosaic, 300 × 285 cm.
Fondation Marguerite et Aimé Maeght,
Saint-Paul-de-Vence.

148. *The Prophet Elijah.* 1970.
Mosaic, 715 × 570 cm.
Musée national Message Biblique Marc Chagall, Nice.

146

147

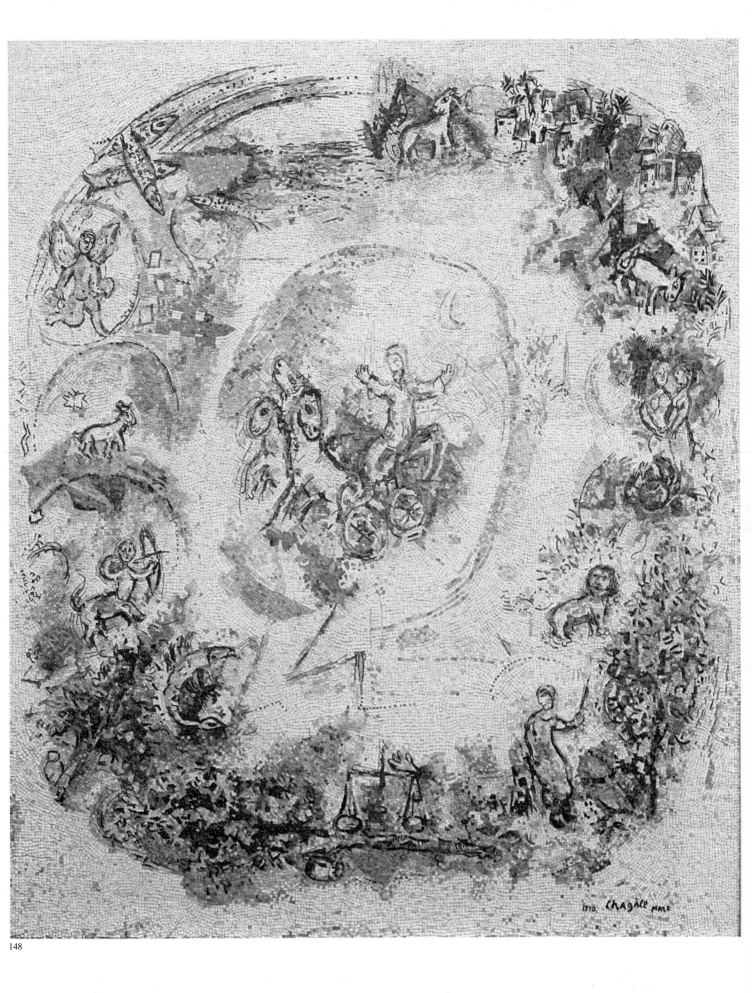

149. *The Patriarchs Abraham, Jacob and Moses.*
Stained-glass window (fragment): on the left, *Jacob's Dream*; on the right, *Moses Before the Burning Bush.*
Cathédrale Saint-Etienne, Metz.

150. *The Creation of the World.*
Stained-glass window: on the left, *The Fifth and Sixth Days*; on the right, *The First Four Days.*
Musée national Message Biblique Marc Chagall, Nice.

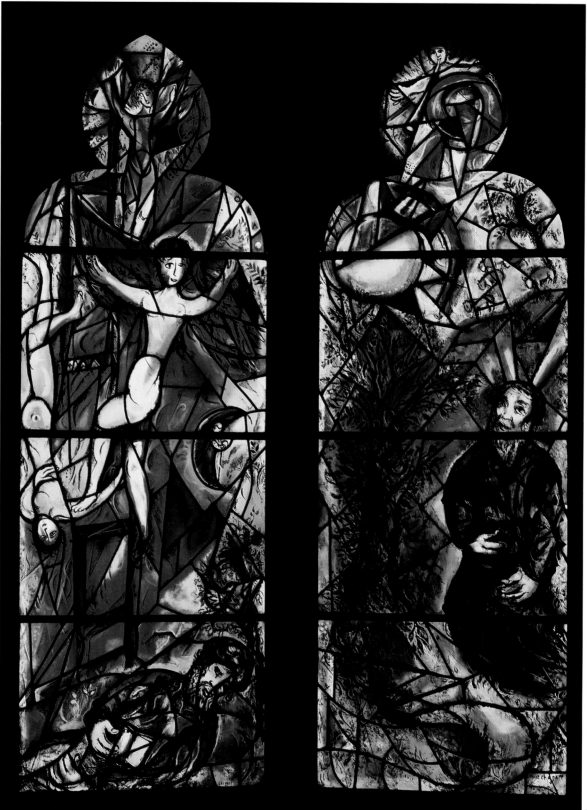

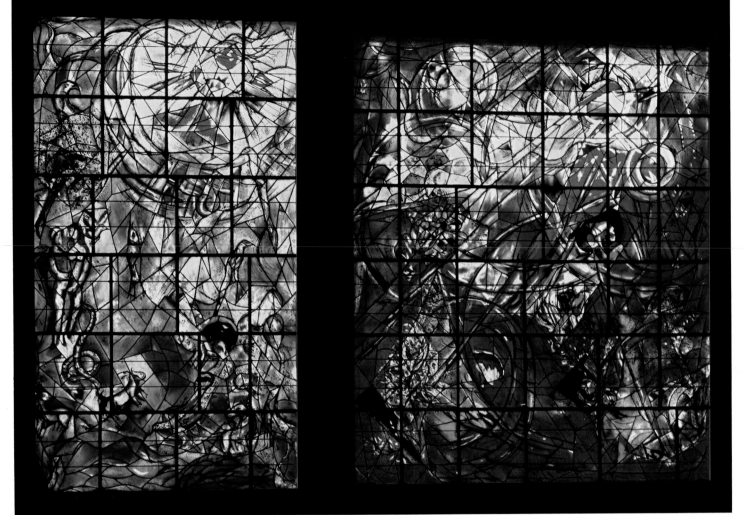

150

151. *The Tribe of Gad* (detail),
 Stained-glass window, 338 × 251 cm.
 Synagogue of the Medical Centre, Hadassah University, Jerusalem.

152. *The Tribe of Issachar.* 1960-1961.
 Stained-glass window, 338 × 251 cm.
 Synagogue of the Medical Centre, Hadassah University, Jerusalem.

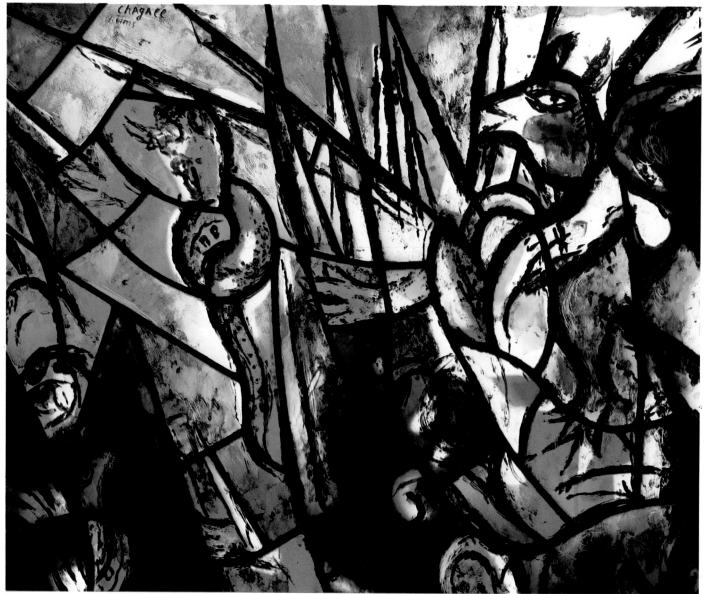

151

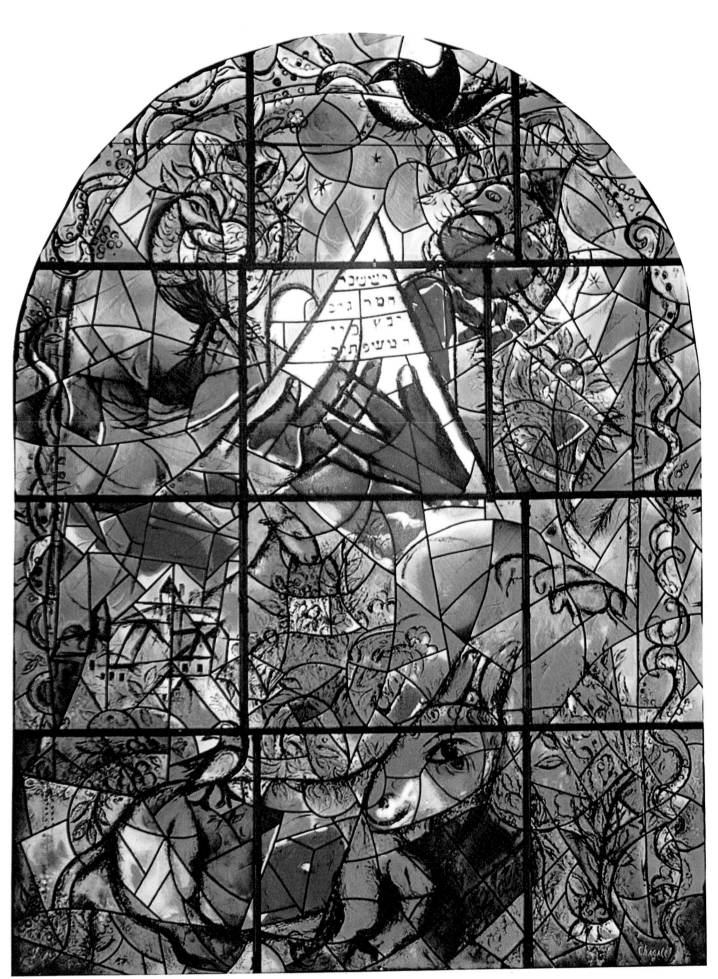

LIST OF ILLUSTRATIONS

1. *The Kermesse.* 1908.
Oil on canvas, 68×95 cm.
Pierre Matisse Gallery, New York.

2. *The Dead Man.* 1908.
Oil on canvas, 69×87 cm.
Private collection.

3. *My Fiancée in Black Gloves.* 1909.
Oil on canvas, 88×64 cm.
Kunstmuseum, Basel.

4. *The Holy Family.* 1910.
Oil on canvas, 76×63.5 cm.
The artist's collection.

5. *The Sabbath.* 1910.
Oil on canvas, 91×95 cm.
Wallraf-Richartz Museum, Cologne.

6. *View of Vitebsk.* 1909.
Pencil and gouache on thick beige paper,
38×29 cm.
Private collection, Paris.

7. *Still Life.* 1911.
Oil on canvas, 63×78 cm.
Mr. and Mrs. Eric E. Estorick Collection.

8. *Nude with Comb.* 1911-1912.
Black ink and gouache on brown paper,
33.5×23.5 cm.
Private collection, Paris.

9. *Nude with Arm Raised.* 1911.
Gouache on brown paper, 28.5×19 cm.
Private collection, Paris.

10. *Cain and Abel.* 1911.
Gouache on paper, 22×28.5 cm.
Ida Chagall Collection, Paris.

11. *Self-Portrait with His Parents.* 1911.
Pen-and-ink drawing, 18×12 cm.
The artist's collection.

12. *I and the Village.* 1911.
Oil on canvas, 191.2×150.5 cm.
The Museum of Modern Art, New York.
Mrs. Simon Guggenheim Fund.

13. *The Fiddler.* 1911.
Oil on canvas, 94.5×69.5 cm.
Kunstsammlung Nordrhein-Westfalen,
Düsseldorf.

14. *The Poet (Half Past Three).* 1911.
Oil on canvas, 196×145 cm.
Philadelphia Museum of Art. The Louise
and Walter Arensberg Collection.

15. *The Birth.* 1911.
Oil on canvas, 46×36 cm.
Private collection, Paris.

16. *The Pregnant Woman.* 1912-1913.
Oil on canvas, 194×115 cm.
Stedelijk Museum, Amsterdam.

17. *Head with Halo.* 1911.
Gouache on brown paper, mounted on
canvas, 20.5×18.5 cm.
Private collection, Paris.

18. *To Russia, to Donkeys and to the
Others.* 1911-1912.
Oil on canvas, 156×122 cm.
Musée national d'Art moderne, Centre
Georges Pompidou, Paris.

19. *Homage to Apollinaire.* 1911-1912.
Oil on canvas, 209×198 cm.
Van Abbemuseum, Eindhoven.

20. *Golgotha.* 1912.
Oil on canvas, 174×191 cm.
The Museum of Modern Art, New York.
Lillie P. Bliss Bequest.

21. *The Soldier Drinks.* 1912.
Oil on canvas, 110.3×95 cm.
The Solomon R. Guggenheim Museum,
New York.

22. *Self-Portrait with Seven Fingers.*
1912-1913.
Oil on canvas, 128×107 cm.
Stedelijk Museum, Amsterdam.

23. *The Odalisque.* 1913-1914.
Black ink and watercolour on brown paper,
20.2×29 cm.
E.W. Kornfeld Collection, Bern.

24. *My Mother.* 1914.
Pencil on paper, 22×20 cm.
The artist's collection.

25. *The Jew with the Stick.* 1913.
Pen-and-ink drawing, 25×13 cm.
Private collection, Paris.

26. *Peasant Eating.* 1913-1914.
Pen-and-ink drawing, 28.5×22 cm.
Private collection.

27. *The Old Man.* 1914.
Pen-and-ink drawing, 25×16 cm.
The artist's collection.

28. *Over Vitebsk.* 1914.
Oil on reinforced cardboard, 73×92.5 cm.
Art Gallery of Ontario, Toronto. Sam and
Ayala Zacks Donation

29. *Feast Day (The Rabbi with a Lemon).*
1914.
Oil on cardboard, 100×80.5 cm.
Kunstsammlung Nordrhein-Westfalen,
Düsseldorf.

30. *The News Vendor.* 1914.
Oil on canvas, 98×78.5 cm.
Private collection, Paris.

31. *The Poet Lying Down.* 1915.
Oil on cardboard, 77×77.5 cm.
The Trustees of the Tate Gallery, London.

32. *Anywhere Out of the World.* 1915.
Oil on cardboard, 56×45 cm.
Private collection, Switzerland.

33. *Bella in a White Collar.* 1917.
Oil on canvas, 149×72 cm.
The artist's collection.

34. *The Green Fiddler.* 1918.
Oil on canvas, 195.6×108 cm.
The Solomon R. Guggenheim Museum,
New York. Solomon R. Guggenheim
Donation

35. *The Apparition.* 1917.
Oil on canvas, 157×140 cm.
Ministry of Culture, Leningrad.

36. *Cubist Landscape.* 1918.
Oil on canvas, 100×59 cm.
Private collection, Paris.

37. *The Man with the Goat.* 1919.
Pencil and watercolour, 360×266 cm.
The artist's collection.

38. *Collage.* 1921.
Pencil, pen-and-ink, papers cut out and
glued, 34.2×27.9 cm.
The artist's collection.

39. *Over the Town.* 1917-1918.
Oil on canvas, 156×212 cm.
Tretiakov Gallery, Moscow.

40. *Sketch for the Introduction to Jewish
Art Theatre.* 1920.
Pencil and gouache on beige paper,
17.5×48 cm.
The artist's collection.

41. Model of the décor for *The Playboy of
the Western World.* 1921.
Pencil, pen-and-ink and gouache on cream
paper, 41×51 cm.
The artist's collection.

42. Costume design: *Woman Carrying a
Child.* 1920.
Pencil and gouache on beige paper,
28×20.2 cm.
The artist's collection.

43. *Over the Town.* Circa 1924.
Oil on canvas, 67.5×91 cm.
Galerie Beyeler, Basel.

44. *Ida at the Window.* 1924.
Oil on canvas, 105×75 cm.
Stedelijk Museum, Amsterdam.

45. *Peasant Life.* 1925.
Oil on canvas, 100×81 cm.
Albright-Knox Art Gallery, Buffalo.
Room of Contemporary Art Fund.

46. *Peonies and Lilac.* 1926.
Oil on canvas, 100×80 cm.
Perls Galleries, New York.

47. *The Chrysanthemums.* 1926.
Oil on canvas, 92×72 cm.
Perls Galleries, New York.

48. *The Basket of Fruit.* 1927.
Oil on canvas, 117×74 cm.
Private collection.

49. *Manilov.* 1923-1927.
(Illustration for Gogol's *Dead Souls*)
Etching and dry point, 28.5×22 cm.
The Art Institute of Chicago.

50. *Asking the Way.* 1923-1927.
(Illustration for Gogol's *Dead Souls*)
Etching and dry point, 28.5×21.5 cm.

51. *The House of the Painters.* 1923-1927.
(Illustration for Gogol's *Dead Souls*)
Etching, 29×23 cm.
The Art Institute of Chicago.

52. *The Dream.* 1927.
Oil on canvas, 81×100 cm.
Musée d'Art moderne de la Ville de Paris.

53. *The Wolf, the Goat and the Kid.*
1928-1931.
(Illustration for La Fontaine's *Fables*)
Etching, 30×24 cm.
Private collection.

54. *The Heron*. 1928-1931.
(Illustration for La Fontaine's *Fables*)
Etching, 29.5 × 24 cm.
Private collection.

55. *The Two Goats*. 1928-1931.
(Illustration for La Fontaine's *Fables*)
Etching, 29 × 23.5 cm.
Private collection.

56. *Still Life Beside the Window*. 1929.
Oil on canvas, 100 × 81 cm.
Göteborgs Konstmuseum, Göteborg.

57. *To Charlie Chaplin*. 1929.
Pen drawing in India ink, 43 × 25 cm.
Private collection.

58. *The Cock*. 1929.
Oil on canvas, 81 × 65 cm.
Thyssen-Bornemisza Collection, Lugano.

59. *Solitude*. 1933.
Oil on canvas, 102 × 169 cm.
The Tel Aviv Museum.

60. *Abraham Mourning Sarah*. 1931.
Gouache on paper, 62.5 × 49.5 cm.

61. *The Rainbow, Sign of the Alliance Between God and the Earth*. 1931.
Gouache on paper, 63.5 × 47.5 cm.
Musée national Message Biblique Marc Chagall, Nice.

62. *Noah Receiving the Order to Build the Ark*. 1931.
Gouache on paper, 62 × 49 cm.
Musée national Message Biblique Marc Chagall, Nice.

63. *Noah Releasing the Dove*. 1931.
Oil and gouache on paper, 63.5 × 47.5 cm.
Musée national Message Biblique Marc Chagall, Nice.

64. *Noah's Garment*. 1931.
Gouache on paper, 63.5 × 48 cm.
Musée national Message Biblique Marc Chagall, Nice.

65. *The Three Angels Received by Abraham*. 1931.
Oil and gouache on paper, 62.5 × 49 cm.
Musée national Message Biblique Marc Chagall, Nice.

66. *Abraham Preparing to Sacrifice his Son*. 1931.
Oil and gouache on paper, 65.5 × 52 cm.
Musée national Message Biblique Marc Chagall, Nice.

67. *The Martyr*. 1940.
Oil on canvas, 164.5 × 139.5 cm.
Kunsthaus, Zürich. Donated by Electrowatt SA, Zürich.

68. *The White Crucifixion*. 1938.
Oil on canvas, 155 × 139.5 cm.
The Art Institute of Chicago. Alfred S. Alschuler Donation.

69. *The Revolution*. 1937.
Oil on canvas, 50 × 100 cm.
The artist's collection.

70. *The Madonna of the Village*. 1938-1942.
Oil on canvas, 102 × 98 cm.
Thyssen-Bornemisza Collection, Lugano.

71. *The Juggler*. 1943.
Oil on canvas, 109 × 79 cm.
The Art Institute of Chicago. Mrs. Gilbert Chapman Donation.

72. *The Red Horse*. 1938-1944.
Oil on canvas, 114.5 × 103 cm.
Private collection.

73. *Obsession*. 1943.
Oil on canvas, 77 × 108 cm.
Private collection.

74. *The Flying Sleigh*. 1945.
Oil on canvas, 130 × 70 cm.
The Museum of Modern Art, New York.

75. *Around Her*. 1945.
Oil on canvas, 131 × 110 cm.
Musée national d'Art moderne, Centre Georges Pompidou, Paris.

76. *The Lights of the Wedding*. 1945.
Oil on canvas, 123 × 120 cm.
Private collection.

77. *The Fall of the Angel*. 1923-1947.
Oil on canvas, 148 × 189 cm.
Private collection, Basel.

78. *The Soul of the Town*. 1945.
Oil on canvas, 107 × 81.5 cm.
Musée national d'Art moderne, Centre Georges Pompidou, Paris.

79. *The Flayed Ox*. 1947.
Oil on canvas, 101 × 81 cm.
Private collection, Paris.

80. *The Horse*. 1949.
Wash drawing, 31 × 38 cm.
Private collection.

81. *Tériade's Garden*. 1954-1955.
Drawing in pencil, 42 × 32 cm.
Private collection.

82. *Tériade's Window*. 1955.
Drawing in pencil, 42 × 32 cm.
Private collection.

83. *Portrait of Vava*. 1953-1956.
Oil on canvas, 95 × 73 cm.
The artist's collection.

84. *To Paul Gauguin*. 1956.
Oil on canvas, 119 × 152 cm.
Private collection.

85. *The Exodus*. 1952-1966.
Oil on canvas, 130 × 162 cm.
The artist's collection.

86. *Roses and Mimosa*. 1956.
Oil on canvas, 145 × 113 cm.
Evelyn Sharp Collection.

87. *The Gladioli*. 1955-1956.
Oil on canvas, 130 × 97 cm.
Gustav Zumsteg Collection, Zürich.

88. *The Song of Songs III*. 1960.
Oil on canvas, 149 × 230 cm.
Musée national Message Biblique Marc Chagall, Nice.

89. *Jacob's Dream*. 1954-1967.
Oil on canvas, 195 × 278 cm.
Musée national Message Biblique Marc Chagall, Nice.

90. *Adam and Eve Driven out of Paradise*. 1954-1967.
Oil on canvas, 190 × 284 cm.
Musée national Message Biblique Marc Chagall, Nice.

91. *Abraham and the Three Angels*. 1954-1967.
Oil on canvas, 190 × 292 cm.
Musée national Message Biblique Marc Chagall, Nice.

92. *The Concert*. 1957.
Oil on canvas, 140 × 239.5 cm.
Evelyn Sharp Collection.

93. *Design for Phileton's Costume in "Daphnis and Chloe,"* 1958.
Pencil, watercolour and pastel on grey Canson paper, 38 × 26.5 cm.
The artist's collection.

94. *The Mermaid of the Baie des Anges*. 1962.
Poster, 99 × 62 cm.
Édition du Commissariat du Tourisme Français.

95. *The Woman with the Blue Face*. 1932-1960.
Oil on canvas, 100 × 82 cm.
Private collection.

96. *David*. 1962-1963.
Oil on canvas, 180 × 98 cm.
Private collection.

97. *Bathsheba*. 1962-1963.
Oil on canvas, 180 × 96 cm.
Private collection.

98. *Paradise*. 1962.
Oil on canvas, 199 × 288 cm.
Musée national Message Biblique Marc Chagall, Nice.

99. *Life*. 1964.
Oil on canvas, 296 × 406 cm.
Fondation Marguerite et Aimé Maeght, Saint-Paul-de-Vence.

100. *Ceiling of the Paris Opera House*. 1964.
Oil on glued canvas, 220 m².

101. *The Clown with Hoops*. 1966.
Oil on canvas, 92 × 65 cm.
Private collection.

102. *The Equestrienne with the Red Horse*. 1966.
Oil on canvas, 150 × 120 cm.
The artist's collection.

103. *The Mauve Nude*. 1965.
Oil on canvas, 140 × 148 cm.
Private collection.

104. *Winter*. 1966.
Oil on canvas, 162 × 114 cm.
The artist's collection.

105. *War*. 1964-1966.
Oil on canvas, 163 × 231 cm.
Kunsthaus, Zürich. Vereinigung Zürcher Kunstfreunde.

106. *Portrait of Vava*. 1966.
Oil on canvas, 92 × 65 cm.
The artist's collection.

107. Model of décor for *The Magic Flute*. 1967.
Pencil, gouache, India ink and newsprint collage, 55 × 74 cm.
The artist's collection.

108 & 109. Costumes for *The Magic Flute*. 1967.
Watercolours.
Private collection.

110. *Jacob's Dream*. 1967.
Oil on canvas, 125 × 110 cm.
Private collection.

111. *The Studio*. 1959-1968.
Oil on reinforced cardboard, 65 × 49 cm.
Private collection.

112. *The Peasants of Vence*. 1967.
Oil on canvas, 112 × 82 cm.
Private collection.

113. *The Birds in the Night*. 1967.
Oil on canvas, 81 × 116 cm.
Private collection.

114. *The Sun of Poros*. 1968.
Oil on canvas, 160 × 160 cm.
The artist's collection.

115. *The Magician*. 1968.
Oil on canvas, 140 × 148 cm.
Private collection.

116. *The Great Circus*. 1968.
Oil on canvas, 170 × 160 cm.
Pierre Matisse Gallery, New York.

117. *Easter*. 1968.
Oil on canvas, 160 × 160 cm.
The artist's collection.

118. *The Painter and His Wife*. 1969.
Oil on canvas, 92 × 73 cm.
The artist's collection.

119. *Orpheus*. 1969.
Oil on canvas, 130 × 89 cm.
Private collection.

120. *The Avenue de l'Opéra*. 1969.
Oil on canvas, 81 × 65 cm.
Private collection.

121. *The Sun Bird*. 1969.
Oil on canvas, 116 × 89 cm.
Private collection.

122. *The Bunch of Buttercups*. 1968-1971.
Oil on canvas, 100 × 73 cm.
Wally Findlay Galleries, New York.

123. *The Clown Lying Down*. 1968-1971.
Oil on canvas, 73 × 92 cm.
Private collection, Milan.

124. *Entering the Ring*. 1968-1971.
Oil on canvas, 92 × 73 cm.
Private collection, Milan.

125. *David's Tower*. 1968-1971.
Oil on canvas, 116 × 89 cm.
The artist's collection.

126. *The Memento*. 1968-1971.
Oil on canvas, 100 × 73 cm.
Private collection, Milan.

127. *The Fantastic Village*. 1968-1971.
Oil on canvas, 92 × 65 cm.
The artist's collection.

128. *The Woodcutter*. 1972.
Oil on canvas, 46 × 38 cm.
Tamenaga Gallery, Tokyo.

129. *The Accordionist*. 1973.
Gouache, 79.5 × 58 cm.
Private collection, Lausanne.

130. *The Circus*. 1973.
Oil on canvas, 55 × 46 cm.
Private collection.

131. *Crucifixion*. 1972.
Black ink, pastel and coloured pencils on pearly Japan paper, 76.7 × 57.4 cm.
The artist's collection.

132. *The Stroll*. 1973.
Oil on canvas, 115.5 × 81 cm.
Pierre Matisse Gallery, New York.

133. *Don Quixote*. 1975.
Oil on canvas, 196 × 130 cm.
The artist's collection.

134. *The Myth of Orpheus*. 1977.
Oil on canvas, 97 × 146 cm.
The artist's collection.

135. *Paris Landscape*. 1978.
Oil on canvas, 130 × 162 cm.
Private collection.

136. *The Fall of Icarus*. 1975.
Oil on canvas, 213 × 198 cm.
Musée national d'Art moderne, Centre Georges Pompidou, Paris.

137. *The Chariot of the Sun*. 1977.
Oil on canvas, 195 × 120 cm.

138. *The Event*. 1978.
Oil on canvas, 130 × 162 cm.
Private collection.

139. *Nocturnal Carnival*. 1979.
Oil on canvas, 130 × 162 cm.

140. *The Great Parade*. 1979-1980.
Oil on canvas, 119 × 132 cm.
Pierre Matisse Gallery, New York.

141. *Couple on a Red Background*. 1983.
Oil on canvas, 81 × 65.5 cm.
The artist's collection.

142. *The Lovers and the Beast*. 1957.
Ceramic, 30 × 22 cm.

143. *The Boat*. 1957.
Ceramic, 33 × 22 cm.

144. *The Profile*. 1957.
Ceramic, 36 × 28 cm.

145. *Christ and the Woman of Samaria*.
Height 52 cm.
Ida Chagall Collection.

146. *The Offering*. 1975.
Mosaic, 665 × 570 cm.
Chapel of Sainte-Rosaline, Les Arcs.

147. *The Lovers*. 1964-1965.
Mosaic, 300 × 285 cm.
Fondation Marguerite et Aimé Maeght, Saint-Paul-de-Vence.

148. *The Prophet Elijah*. 1970.
Mosaic, 715 × 570 cm.
Musée national Message Biblique Marc Chagall, Nice.

149. *The Patriarchs Abraham, Jacob and Moses*.
Stained-glass window (fragment): on the left, *Jacob's Dream*; on the right, *Moses Before the Burning Bush*.
Cathédrale Saint-Etienne, Metz.

150. *The Creation of the World*.
Stained-glass window: on the left, *The Fifth and Sixth days*; on the right, *The First Four Days*.
Musée national Message Biblique Marc Chagall, Nice.

151. *The Tribe of Gad* (detail),
Stained-glass window, 338 × 251 cm.
Synagogue of the Medical Centre, Hadassah University, Jerusalem.

152. *The Tribe of Issachar*. 1960-1961.
Stained-glass window, 338 × 251 cm.
Synagogue of the Medical Centre, Hadassah University, Jerusalem.